# THE SCULPTED FOREST

# THE SCULPTED FOREST
## Sculptures in the Forest of Dean

RUPERT MARTIN

With an essay by Martin Orrom
and texts by the artists:

BRUCE ALLAN
PETER APPLETON
KEVIN ATHERTON
ANDREW DARKE
ZADOK BEN DAVID
MILES DAVIES
IAN HAMILTON FINLAY
STUART FROST
MAGDALENA JETELOVA
TIM LEES
YVETTE MARTIN
DAVID NASH
CORNELIA PARKER
PETER RANDALL-PAGE
SOPHIE RYDER
KEIR SMITH

and photographs by Sarah Quick and Jamie Woodley

REDCLIFFE
Bristol
With financial support from the Henry Moore Foundation
and the Forestry Commission.

First published in Great Britain by Redcliffe Press Ltd, 49 Park Street, Bristol.

Designed by Jem Southam.

*The Forest of Dean Sculpture Project was established in 1986 by the
Arnolfini Gallery, Bristol in collaboration with the Forestry Commission,
with funding by The Carnegie United Kingdom Trust, The Elephant Trust,
The Forestry Commission, The Henry Moore Foundation and South West Arts.
It was completed by Art Landmarks and The Forestry Commission in 1988
with additional support from The English Tourist Board, The Ernest Cook Trust,
The Forest of Dean District Council, and Gloucestershire County Council.*

All photographs by Jamie Woodley & Sarah Quick, except for
Rupert Martin pp 20, 24, 46, 58, 59, 67, 73, 77, 79, 81, 84, 91; Fay Godwin p 14;
Andrew Darke pp 19, 33, 64; Harry Scott p 56; Meg Robbins p 68.

British Library Cataloguing in Publication Data
The Sculpted Forest: sculptures in the Forest of Dean.
1. English sculptures – Catalogues, indexes
I. Martin, Rupert
730.942074

ISBN 0 948265 04 3

Typeset by Alphaset, Bristol. Printed and bound by Taylor Brothers, Bristol.

# CONTENTS

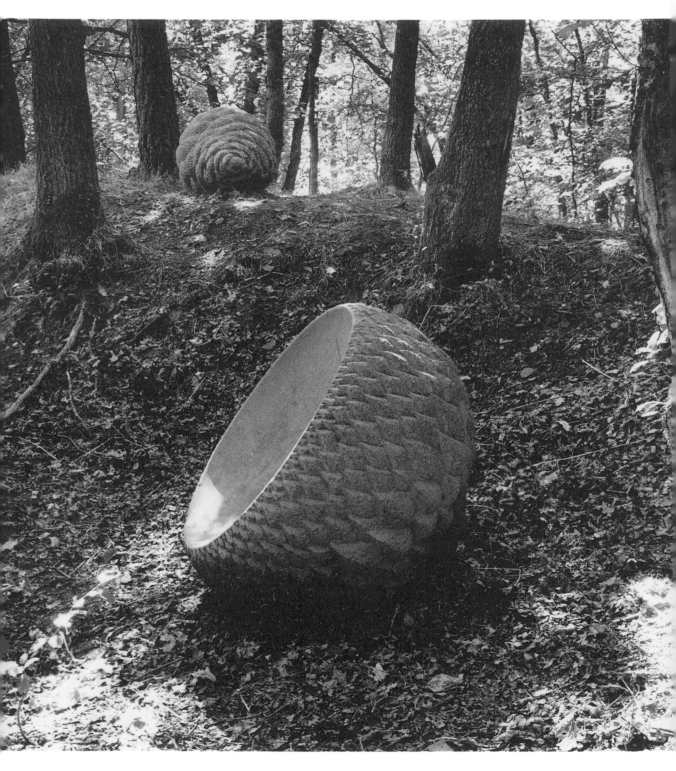

# INTRODUCTION

The two phases of the Forest of Dean Sculpture Project spanning a period of five years have involved sixteen artists, and have left eighteen works of art in the Dean. These are situated on a four mile circular walk. Rather than commissioning further sculpture, which would crowd this part of the forest, it was felt that attention should be concentrated on the maintenance of the existing sculptures and the paths between them. The Forestry Commission has undertaken to carry out this work, with recommendations from a Trust that has been set up to advise on the works of art.

The project now has a life of its own, and is used by many individuals and groups, especially schools in Gloucestershire, who have completed a number of projects relating to the sculptures. It has great educational potential, and is helping to introduce a younger generation to an art that is accessible and enjoyable. The project is also a good precedent for future ventures of a similar kind.

So many people have been involved in this project that it is difficult to thank everyone by name. I would like to begin by thanking Martin Orrom, former Environment and Private Forestry Officer of the Forestry Commission, West England Conservancy, who had the vision to see the potential of such a project, and the genius to bring together artists and foresters into a working partnership through the mediation of an art gallery. The artists and all those who assisted them deserve considerable thanks both for the imaginative qualities of their sculpture and photography, and the sheer determination required to make work in and for the forest. They in turn were fully supported by the Forestry Commission, including John Fletcher, Conservator, Rod Leslie who succeeded Martin Orrom; and in the Dean itself, Jeff Carter, Sue Tomlinson, John Anderson, Peter Ralph and Gary Trigg, whose hospitality was very welcome to all the artists-in-residence.

On the Arts side thanks are due to those involved at the outset, Jeremy Rees, Alister Warman and Anthony Stokes, as well as those at Arnolfini Gallery who helped carry out the work, Andrea Schlieker, Frances Morris, Jane Connarty and George Coulsting. The contribution of the photographers commissioned in the first phase, Keith Arnatt and Fay Godwin, was also a crucial one,

*Peter Randall-Page, Vessel and Cone, 1988, Forest of Dean stone.*

creating enduring images of the forest that will be important visual documents for years to come. The educational side of the project involving workshops for children and adults, and in-service training for teachers, was ably co-ordinated by Tim Staples and Andrea Nicholson in 1986, and subsequently by Janette McSkimming and Lindsey Fryer at Arnolfini Gallery and by Julian Davies and Arthur Penn, working for the Gloucestershire County Council Education Authority.

Finally I would like to thank all those who have made the project possible through their generous financial support; The Carnegie United Kingdom Trust, The Elephant Trust, The Forestry Commission, The Henry Moore Foundation, and South West Arts all of whom contributed to both phases of the project; as well as The English Tourist Board, The Ernest Cook Trust, The Forest of Dean District Council, and Gloucestershire County Council, who supported the second phase.

The sculptures remain as a tribute to the people who live, work and continue to make their mark on the landscape of the Dean, and they show what can be achieved in a creative partnership which makes art accessible to all and which enhances people's understanding and enjoyment of the forest itself.

Rupert Martin, Bristol, April 1990.

MARTIN ORROM

# SCULPTING THE FOREST STORY

Forests have always been places of mystery for man. Their hidden interiors have provided homes for fugitives and hermits. They have also harboured wild creatures: wolf, bear, wild boar and deer. Sadly only the latter remains in Britain. Besides providing shelter for man, the forests have yielded timber for building and burning, coal and iron, and food in the form of nuts, berries, mushrooms, venison and other game. The mystery of forests and the seasons has inspired rituals and different types of tree have a different magic. In recent times artists and writers have responded to the beauty of forests, and many fairy tales use the background of a forest to heighten the drama. Today the outlaws and beasts of prey have gone, and the greatest risk for the visitor is probably losing one's way. Yet the rest of the mystery, diversity and seasonal renewal is still there ready to be discovered and inspire those who will look.

Today, visitors are attracted to forests for the shelter they offer from strong wind or sun and a chance to escape a sense of overcrowding. Visitors enjoy the forest provided they are offered the guidance of well signposted paths. A study in the 1960s showed how much visitors enjoyed a good walk and at the same time how little inclination they had to study their surroundings. Notices and leaflets associated with the new fashion for nature trails have had only a modest success. The deeper wonder of it all was passing people by. They enjoyed the natural beauty in an unquestioning and placid way.

Since Forestry Commission forests are a national heritage, their foresters are happy to encourage visitors and would like to see them experiencing a deeper enjoyment than just fresh air and exercise. Such a wish is not wholly altruistic. There is a belief that if visitors go away with a greater understanding they will be more likely to conserve the forests for the future.

The question has been how to open visitors' eyes to the hints of history, the sense of awe and magic; above all to the sense of beauty of a living and

productive environment. Foresters and natural scientists are perhaps too prosaic, too close to the text books which trained them. Could it be that artists who come with no specialist knowledge would be able to inspire visitors with works of art which are both a direct response to the forest and to the very spot where the work is placed?

The first sculpture trail which turned out to be a pilot for the Forest of Dean Project was a trail with a narrative in Exeter Forest, created by just one artist: Jamie McCullough. Here he built and sculpted more than a dozen works, most of which demanded an active response from visitors. These included a maze, two narrow and curved suspension bridges which flexed as they were stepped on, a vertical acorn cup which mysteriously always had acorns in it, a curving dark tunnel which led to a ladder up into a forester's hut, a rose window made of branches hung in tall trees, and finally an open sided building with a stone fireplace where food was often left in stone niches. It was a walk to appreciate for its challenges and for its moments when one just stood, stared and listened. Designed, therefore, for a contemplative public in family groups it rapidly became a popular success. Hundreds walked it every weekend and the fragility of some parts was shown up. The popularity was all the more surprising since no reporting was permitted despite offers from TV and colour magazines. Everyone learned of it by personal recommendation and roughly drawn maps passed from hand to hand. Eventually, after two or three years it became just an adventure playground for it had been strengthened and altered to accommodate the numbers using it. In its heyday adult visitors said that it carried them back to a sense of wonderment they had not experienced since they were children.

The funding for this two year development, named *Beginner's Way,* came principally from South West Arts, The Carnegie United Kingdom Trust and the Dartington Trustees. Considerable help was given by the Forestry Commission. The project came about through a contact between the Arts Council's Alister Warman and Martin Orrom of the Forestry Commission. The Arts Council suggested that Jamie McCullough was looking for a forest to work in and the Commission agreed to help, provided the artist was prepared to interpret the forest for the public and not merely to place previously conceived sculpture in beautiful places.

As the project took shape Jeremy Rees, then Director of the Arnolfini Gallery in Bristol offered the Gallery's help in furthering the movement of commissioning artists to interpret the forest. This generous offer was made dependent upon the Forestry Commission remaining enthusiastic and

committed to seeing through a new trail in another forest. Success would come only from a close partnership between landowners, art organiser and artists.

The next stage was to settle on the form of a second trail. *Beginner's Way* could not be repeated; the artist did not want to attempt a similar narrative trail and it was felt that the formula in other hands could easily fail. The plan which evolved, therefore, depended on selecting a varied forest of mixed ages and species in order that a group of artists could be offered a wide range of sites and environments from which to choose one to interpret. The forest needed to be within easy reach of the organisers in Bristol, so the choice of the Forest of Dean was almost automatic. This is an ancient Royal forest half of which is still growing the oak and beech which are native to the area. The remainder of the forest is an intimate mixture of relatively small blocks of conifers and mixtures of conifers and hardwoods. There is a strong industrial history connected with charcoal making, coal mining and iron smelting. Within the forest there are trees which date back to the reign of Charles II in the 17th century.

An early decision was taken to commission works so that they became the property of the landowner, the Forestry Commission. This meant that the Forestry Commission would have to put up part of the money for the project. This broke new ground for them but nevertheless it was agreed and the decision later paid handsome dividends. Once the prime mover, the landowner, had committed cash to the project other money was promised. The first came from the Elephant Trust to enable the planning teams, which now included Rupert Martin, Exhibitions Organiser at the Arnolfini, to engage a freelance curator to assemble a preliminary list of artists and to invite them to come down to the Forest of Dean. The trail area was decided as forest within a radius of 30 minutes walk around Speech House hotel, the centre of the present forest. The artists included sculptors, photographers, painters, writers, performance artists and a dance choreographer. They were invited in three groups of six to visit overnight and be shown round by forest staff. After their visit they were asked to write and describe what they would do if commissioned. The commissioning brief was simple; the work must interpret the forest for the visiting public and encourage them to explore the forest on foot and to use their imagination about some aspect of its past or current activities.

By now plans for the second trail had been discussed with foresters in the Forest of Dean and senior regional staff. There was no outright opposition;

many thought it a good idea, others were prepared to give it a trial in a more non-committal way. However, progress was assured with the wholehearted backing of the Conservator, John Fletcher. Naturally, long term placements of sculpture could bring constraints to forest management. The forest is a crop and trees have a natural life span. To keep crops standing after this may cost money, so in selecting from the artists' proposals, future forest management had to be borne in mind. The team were not planning an interpretation of an urban park but a living, producing forest. One which produces 60,000 tons of timber annually for sale and which should continue on this scale in perpetuity.

As the enthusiastic proposals came in, the budget was also taking shape and so began the difficult task of selection from the artists who had visited the Dean. It had been decided that a new trail should be established around the Speech House linking the selected proposals like beads on a chain. In parts this required the construction of a new path. At first the team were in favour of low-key signposting and mapping of the trail so that a walk in the forest should become a voyage of discovery. How unpopular this notion proved! The public were to demand a strongly marked and signposted trail linking the works and became most indignant if through ambiguity or lack of signing they missed one!

The works were selected to provide six major stops using contrasting materials and techniques. They were also selected with consideration for how much support the Forestry Commission would have to provide in terms of manpower and materials. Each site was agreed after foresters had checked it for relatively long term stability and also for the avoidance of hazards such as blocking extraction routes for timber.

The area around the Speech House has much 150-year-old oak woodland native to the Dean. In addition there are some attractive mixed woods and also areas of conifer such as Scots pine, larch and Douglas fir. There are streams and lakes. The slopes within the area give the visitor the chance of some long views over other parts of the Forest. All in all it is a beautiful area with changes at every turn of the path. Yet until the advent of the sculpture trail it was little visited.

The selection did not aim to produce any narrative as in the case of *Beginner's Way*. Nor were the artists influenced one by another; nevertheless they fortunately spread themselves out so that a trail could be made to link them taking about 1½–2 hours with only short stops. Artists cannot always plan to

the last detail well in advance and we had some surprises in the run up to opening—extra bulldozers, cranes, holes in the ground and manpower had to be conjured up to open on time, but it was worth it.

The integrity of the artists shines through in their work and in their persons. They quickly established a respect from foresters by their sheer commitment to long hours and hard work. They were ready listeners to the forestry point of view. They spoke about their work and explained it easily to the public as they erected it on site.

The public for their part—that is foresters, planners, local residents, tourists and the media—seem to come with open minds and to be willing to discover what the artist is saying in this beautiful, open-air gallery. The usual negative response to modern art is avoided. The public penetrate deep into the forest on the trail in search of the sculpture, consider it, like some and not others, each having a different opinion. There is no universally favourite piece and what is most important, visitors certainly look at the forest, at its mystery, diversity, history and scale with a new eye. Children love it and respond to it with more art and writing too. The popularity of the trail is demonstrated by the deep ruts left by visitors' feet on the recently opened walk.

The role of this sculpture trail has been described as one of interpretation of the Forest of Dean. It differs from sculpture parks such as Grizedale Forest or Portland in that every piece was commissioned as a response to its final resting place. In some parks the development of the artist often comes first and works are made during a residency. There is little or no selection. In others, famous works are moved into sites probably not even chosen by the artist.

All the sculptors working in the Dean were entranced by the location and felt uplifted by the forest around. They contrasted the spaces between the sculptures with the neutral or even sterile walls of an art gallery and said how much their works were enhanced by the walk around the trail.

The public appear to regard the trail as a hunt for treasure. There is an excitement and a willingness to talk and share experience which is not found on other trails in the woods. The number of people who walk deep into the woods is much greater than ever before.

RUPERT MARTIN

# THE FOREST OF DEAN SCULPTURES
## A Way into the Forest

## PROLOGUE

Even though there were good precedents for works of art being made in forests such as Grizedale and Exeter Forest, my first reaction was that sculptures in the forest would be absorbed and lost like drops in the ocean. A preliminary meeting between Jeremy Rees, Director of the Arnolfini Gallery, Martin Orrom, Environment Officer of the Forestry Commission, West England Conservancy and Alister Warman, Public Arts Officer at the Arts Council, had established that collaboration between the Forestry Commission and a contemporary art gallery could be fruitful. With initial funding from The Elephant Trust artists were invited to the Forest of Dean, to elicit from them a response to the forest and ideas for projects in specific places, the underlying purpose being to interpret the forest. At this stage the concept extended beyond sculpture to include photography, painting, dance, music and literature. The early meetings reflected this concern to integrate various art forms, and the first meeting on 28 March, 1984 included two photographers, Keith Arnatt and Fay Godwin, two painters, Ian Mckeever and Paula Rego, and a choreographer, Ian Spink. The second meeting on 14 April included four sculptors: Kevin Atherton, Nicholas Pope, Andrew Darke, Jonathan Froud and a performance artist, Bruce McLean.

The part of the forest chosen by Martin Orrom to explore centred on the Speech House at the centre of the Dean, starting on the brow of the hill, going down to an old disused railway line in the Cannop Valley, and up again past the Beechenhurst picnic site. As well as Martin Orrom, another Forester was

*Fay Godwin*, Fence, Russell's Enclosure, *1985*.

present to answer questions about the practice of Forestry. The artists stayed overnight and were able to explore the forest on their own the following morning. The meetings set the scene for the whole project, with the emphasis on allowing artists the time and space to make a direct response to the forest and to discover it for themselves. Although such visits were time-consuming, they were an essential ingredient, enabling original and unusual ideas to germinate. In the end only five of these ten artists became involved in the project, but the responses of those who weren't proved to be intriguing. Ian Spink wrote: "My initial reaction to all that timber, young and old, was one of awe at its solidity and its incredibly slow growth, mixed with a feeling of the fragility of the forest." Nicholas Pope proposed a collaboration with the writer Kevin Mount whose research revealed some interesting source material about the work of charcoal burners. Bruce McLean suggested collaborating with an architect to produce a tower or folly overlooking a lake and surmounting the tops of the trees. After the initial meetings there was a lull while efforts were made to find funding for the whole project. The Forestry Commission had agreed to contribute each year over a three year period, but the breakthrough came when the Henry Moore Foundation offered a substantial grant which made the whole concept feasible and enabled some large-scale work to be undertaken.

Other artists invited to visit the forest included Keir Smith, Rosie Leventon, Don Rankin, David Nash, Stuart Frost, Peter Appleton and Magdalena Jetelovà. The selection of artists to invite was made on several grounds; their experience in working outside, their adaptability to a new environment and whether their work would be suitable for exposure to the elements. Several artists did not come back with proposals, whilst some proposals proved to be too expensive, so the selection of work to commission came down to what was most imaginative and appropriate to its site, whether the work could be integrated and whether it was affordable. All the practical considerations were, however, subsumed within the one overriding question of the relationship of the sculpture to its chosen place.

From early on it was established that the forest itself was the main subject of the project, the leading player, with the sculptures as the supporting cast. The spaces between the sculptures were to be as important as the sculptures themselves. The original title of the project *Stand and Stare* incorporated the concept that the sculptures were there to arrest our attention, cause us to pause and contemplate both the isolated object and its surroundings. They were to act as catalysts for our imaginations, releasing new ideas in us about our relationship to nature and the environment, and prompting a sense of awe and wonder.

# THE FOREST OF DEAN

Since 1924, the Dean has been managed by the Forestry Commission, and efforts have been made to preserve the balance between deciduous and coniferous trees that gives the Dean its special character. The Dean has always been renowned for its oak which was particularly suited to ship-building, and the oaks of the Cannop Valley date back to Nelson's day. Another feature is the intimate nature of the plantings of other tree species besides oak. From one side of the Sculpture Trail to the other, in the space of a mile, you can see seven plantations—beech, Sitka spruce, larch, birch, oak, Douglas fir, and Scots pine. This area of the Dean along the Cannop Valley has been planned for conservation and recreation, and recently designated a National Forest Nature Reserve, one of only seven in the country which exceed 500 hectares. This means that the trees will be allowed to live longer than a purely economic span and will probably be regenerated from their own seed. In addition, some fallen trees will be left to decay and provide habitats for wildlife.

Another aspect of the Dean is the frequency with which one discovers signs of man's presence, enigmatic indicators of industry and mining; railway tracks, disused gates, bridges, troughs and hollows, revealing ancient excavations whose purpose often remains unknown. It is a forest of secret signs, a place that man has worked and abandoned, and is now reclaiming. The forest is no idyllic, unspoiled landscape, and cannot be separated from the hard grind of industry, the sweat and danger of mining which has left the forest map produced by Sopwith in 1825 covered in names that tell their own story: Croesus, Go on and Prosper, No Coal, Pluckpenny, Rain-proof, Small Profit, Snatch Crust, Speculation, Strip-and-at-it, Work or Hang. Other mines indicate the date when they were opened, such as Trafalgar and Collingwood, whilst others have a curious poetic resonance, Thatch, Rose in Hand, New Found Out, the last one still being worked by a free-miner. Near Cannop ponds, an iron foundry was set up in the reign of Charles II, and one can still see the watercourses that fed the water into the ponds. The vestiges of charcoal burning are less easy to find, consisting of flat circular spaces and hollows. Between the Cannop Brook and the road, there are pits hollowed out by striking miners in the 1920's looking for surface coal. More recently the new machinery for extracting timber has left huge ruts and tracks. The sculptors add one more layer to this network of landmarks and signs in the forest.

The forest has for centuries been a place of work, of fiercely guarded rights to mine, quarry, run sheep and collect wood. Its situation between Wales and England, the rivers Wye and Severn, has isolated it from the rest of the country until recently, when new bridges and roads have made it more accessible. People not born in the Dean, however, are still called foreigners. The sculptures could be seen as an intrusion into this history, but the work of carving, moulding and constructing is in essence a continuation of the history of workmanship and craftsmanship in the forest. Such work is not productive in the manufacturing sense but in a more spiritual sense, since it meets the needs of our increasingly secular and materialistic society to find something in nature that is absent from our urban culture; a serenity and peace that comes from the contemplation of a tree's growth, an attentiveness to the sound of streams and the scurryings of insects, the unfolding or falling of a leaf. If we see the forest as lungs incorporating the breath of God and a tree as God's immaculate sculpture, then the sculptures in the forest, as with all the other vestiges of man's labour, are part of the same creative spirit which points to the particular character, at once congenial and sublime, of that society of trees which we call a forest.

## THE FIRST SCULPTURES—1986

There is a story attached to each of the sculptures made for the Dean but it is a story that is constantly changing. The sculptures are not static, finished objects, protected from the elements. Change and decay are part of their character. In that sense the sculptures resemble the trees beside which they are placed. Like them they are exposed to the force of wind and rain, and are vulnerable to decay. Neither are they permanent, although depending on the materials, some are more permanent than others. Their appearance alters according to the season, the time of day and the weather conditions, making it worthwhile to revisit them at different times of the year in order to see them in a new light.

The first work to be placed in the forest was the *Sliced Log Star* by Andrew Darke. Having moved from Yorkshire to the Dean to make the most of the availability of wood, Darke was more familiar with the forest than the other artists. His work explores through minimal form and rhythmic patterns the character of tree and wood. One of his two proposals was for a spiral planting of different species of trees to reveal over the years the different pace of growth and the shape of each species. The second proposal, which was the one commissioned, is a tribute to the interior life of the tree. With the help of a sawyer in a local saw-mill, he skilfully dissected an oak tree into eight

*Andrew Darke,* Sliced Log Star (Inside-out piece), *1985, oak.*

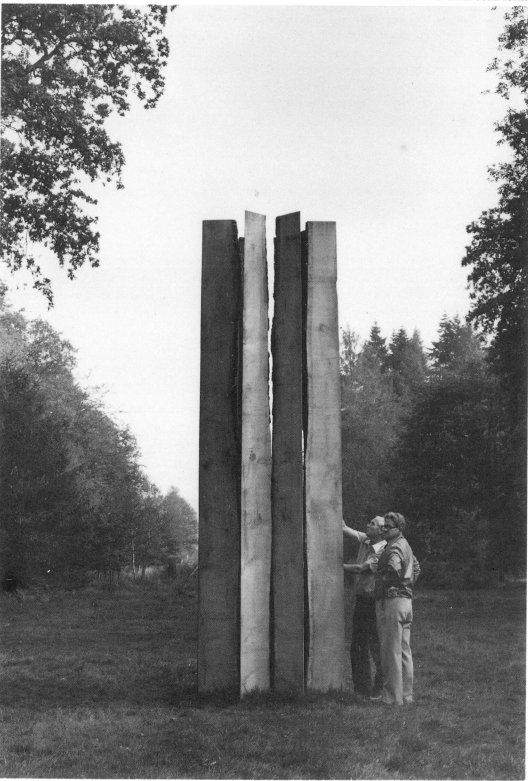

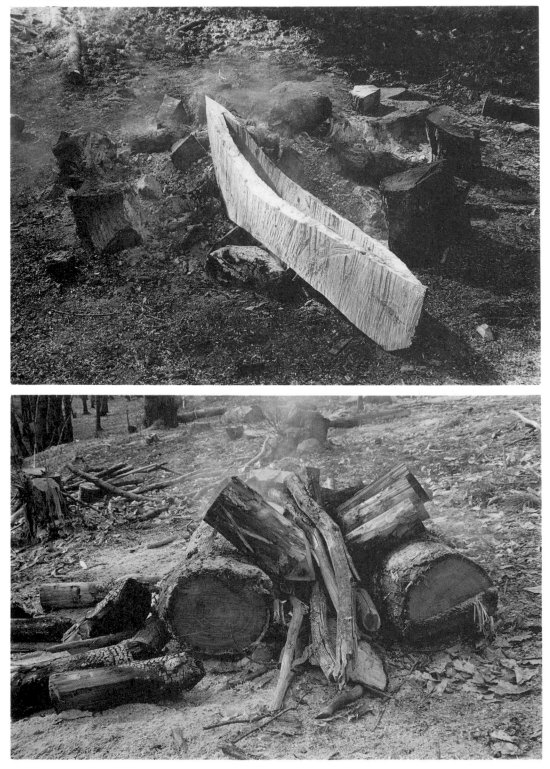

segments, before placing them inside-out in a star shape near the Speech House, at the focal point of the long Spruce Ride. The space enclosed by the segments is the same as that which the tree originally occupied, and the work has weathered to a silvery grey. The idea is clearly realised and the juxtaposition of the sculpture next to an oak tree of a similar age is particularly appropriate. The formal aspects of the work are indicated in a nearby small-scale work which shows the tree in the process of being turned inside-out.

David Nash wanted his *Black Dome* to be like a 'mood' in the landscape, a quiet presence which absorbs the light and embeds itself within a circle of oak trees like an ancient burial mound. From the height of the railway embankment it appears as a smooth regular shape, a counterpoint to the irregularity of tree, leaf and bracken. On closer inspection the vitality of the work becomes apparent as it bristles with the latent energy of its upturned charred stumps, which in the words of one young boy resembled a hedgehog. The subtlety of the piece allows the imagination free play in its associations, so that at one moment you may see in miniature a mountainous or a wooded landscape, at another something like the giant's causeway. The sculpture was made to incorporate change, and although charring is a traditional way of preserving wood, it will eventually be absorbed back into the earth. David Nash's work is a collaboration with nature and with the forces of growth and decay, involving the elements of fire, water, earth and air. One aspect he did not foresee is the way in which children would want to climb on it, but he sees the polishing effect of their shoes as giving it a new character, "like a stroked cat".

For something so peaceful and calm, an extraordinary amount of effort went into its making. Each of the nine hundred larch logs had to be cut and tapered using a chain saw, charred in a fire made from wood from a nearby oak, graded according to size and wired into position. It rained during most of the four weeks it took to make in April 1986, and the place turned into a quagmire. With a trail of smoke rising up into the sky from the fire, the charred logs, and the sound of the chain saw, it resembled an epic battle out of Beowulf. The plume of smoke reminded one of the process of charcoal burning that provided part of the inspiration for the work, which resembles a charcoal burner's stack. But the final effect transcends such specific references to provide something that glows like the embers of a fire against the green bracken and focusses our attention for a while on the tranquillity of the place.

The *Fire and Water Boats* were made in response to a wooded glade that the artist discovered nearby, through which a man-made watercourse runs. The

*One of David Nash's* Fire and Water Boats *being launched into the flames.*
*Tapered logs being charred for David Nash's* Black Dome.

secluded hollow concealed by the overarching beech and oak trees echoes with the sound of running water that filters out of the bank and through a bed of watercress. On this marshy ground Nash placed six charred boats, the three solid shapes hollowed out from the three canoe shapes, all pointing downstream towards the entrance to a small tunnel. From the bank the boats appear like a flotilla marooned inland, or like a group of vessels in a burial ceremony, which have passed through the elements of fire and water.

Nearby Keir Smith takes us on another journey. *The Iron Road* consists of a series of twenty interrelated images carved out of wooden railway sleepers, comprising a tactile poem in which each image relates to the whole. The sculpture evokes the passage of time in its gentle elegaic way, recalling the original use of the railway line between Cinderford and Lydney, and the decline of the traditional forest industries. By blending rural and industrial images, Keir Smith has conveyed the character of the Dean. But although they are highly legible, they have a symbolic meaning that extends beyond the forest to a sense of the transience of things and the possibility of their redemption. There is a delight in ordinary things in the first six images of feather, book, arrow, leaf, worms and water jug. This familiar world is supplanted by images of industry, fire and destruction which follow. The last section shows the sun bursting through the clouds, the butterfly emerged from the chrysalis and the images that are earthbound in the first section, the feather and book, lifted up on clouds in a celebration of the poetic spirit. The clouds blown by the wind are depicted in the traditional way with the face of the wind being a self-portrait of the artist.

It is no coincidence that Keir Smith is also a poet, since this sculpture works in a poetic way, accumulating images that relate to one another in a sequence that progresses from earth to heaven via the industry of man. This movement through time and space is accentuated by the placing of the work on the curve of the railway line, overshadowed by silver birch trees, which in autumn cover the images with their leaves. The sequence is both finite and infinite, stretching in the mind's eye into the distance, and involving both our active participation in walking through the sculpture and our imagination in interpreting the images for ourselves.

When Magdalena Jetelovà visited the forest in 1985, a large area of trees had recently been cut down, revealing a magnificent view of the Cannop Valley. Her initial idea was to place a giant chair-like structure as if clambering over the embankment of a forest road onto the ridge. As this would have obstructed the movement of Forestry Commission vehicles, a special mound

*Keir Smith*, The Iron Road, *1985–6, jarrah wood.*

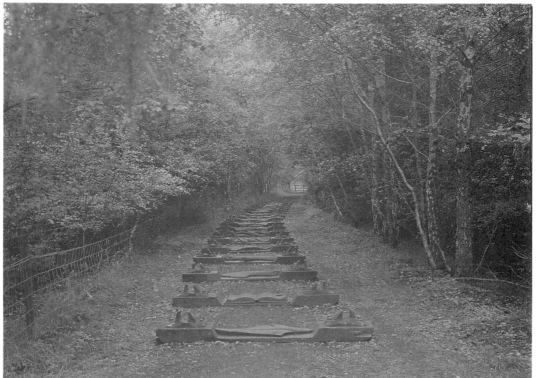

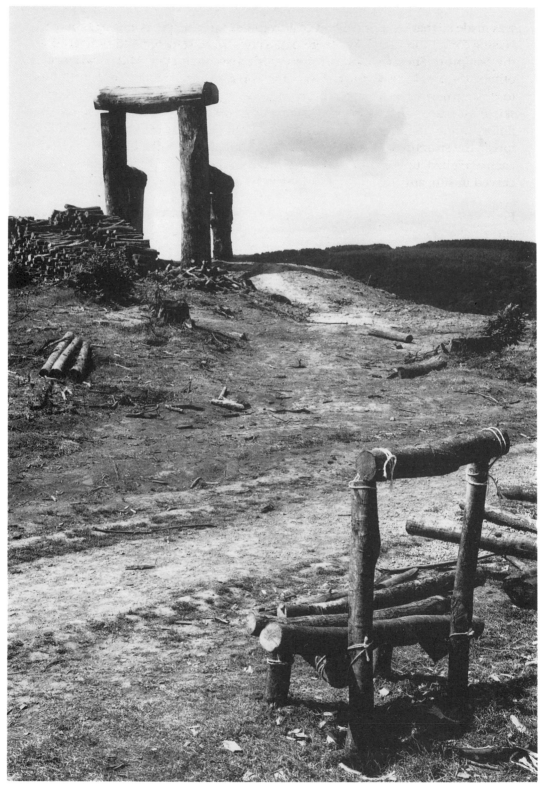

was made so that the same effect of movement up and over could be achieved. Having found the place, five large oak trunks were selected and delivered to the Sculpture Shed in Bristol, where with assistance from Miles Davies and others, the trunks were moved into position for the tenon and mortice joints to be cut using chain saws. These joints were cut with great precision and skill, since the strength of the structure depended on the dovetailing of the limbs, which interlock almost seamlessly. After six months weathering in the forest, the structure was put up, using a 10-ton crane to hoist the trunks which each weighed up to four tons into position. The final capping piece was carved in situ, and keeps the whole structure in place with its weight.

Entitled *Place,* the sculpture is a place both to walk to, and from which to survey the landscape. It is not just an object to look at, but with its skeletal construction, a portal or gate through which the valley can be framed. It has become known as the 'Giant's Chair', the throne of some creature whose domain is the forest. With its irregular gait it has the look of an animal traversing the land, and brings to mind the myths and fairy tales of our childhood. It is also an almost abstract structure, with its rhythm of horizontals and verticals changing from each angle to form an asymmetrical composition. The character of the sculpture varies with each season, so that its harsh face in winter becomes benign and welcoming in summer. When first constructed it overlooked the devastation of a slope of recently felled trees, like an overlord surveying the scene of some battle. In summer the slope was clothed in pink foxgloves and soon, as the new pine trees grow, a sea of green will break like waves at the foot of the chair. Comparisons have been made with Henry Moore's *King and Queen*, placed on a hill slope above a lake in Dumfriesshire. With its human scale and figuration, Moore's work has an unassuming intimacy and sense of human frailty and companionship. In its bold isolation and dramatic scale, Jetelova's work has by contrast an awe-inspiring grandeur. The work expresses some of the ideas which she developed out of the oppression in her native Czechoslovakia, where the monolithic state dominated every aspect of life. She has written that what fascinates her is "the possibility of expressing constant change in these objects". That change is provided by the changing nature of the forest.

Kevin Atherton's work is entitled *Cathedral,* because it incorporates the whole wood in which the stained glass window is placed. Being a city dweller at heart, Atherton's idea was originally to do something in opposition to the forest, such as constructing a short section of motorway! This idea wasn't well received and he developed his idea of stained glass windows running along both edges of a wood. The cost of this led to the idea of an East and a West

*Magdalena Jetelovà's* Place *overlooking the Cannop Valley, with chair made during a children's workshop in 1986.*

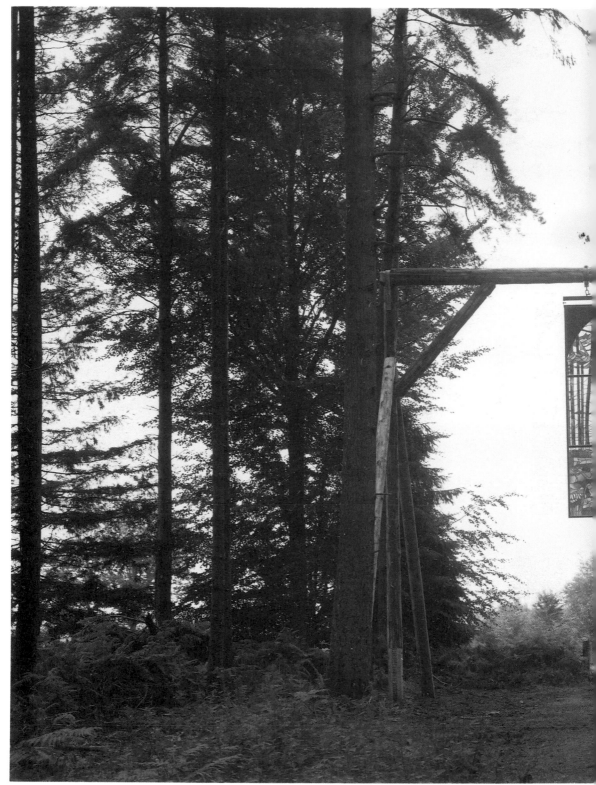

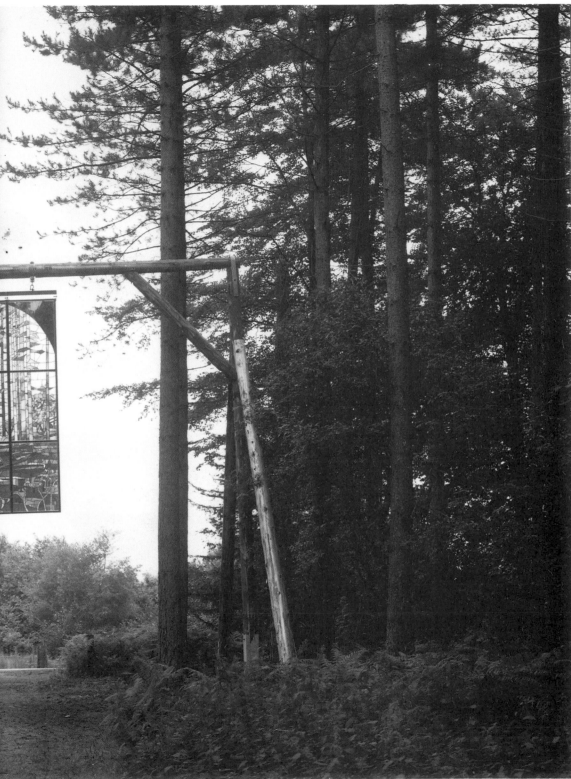

*Kevin Atherton,* Cathedral, *1985–6, stained glass.*

facing window, which eventually had to be reduced still further, so that one window was eventually sited at the end of a long tree-lined aisle facing East. Even this solution nearly didn't materialise, as the costs mounted, and the Foresters anticipated vandalism. Key factors in realising this ambitious project were that Martin Orrom who was particularly attached to the idea, kept his nerve, and sponsorship was obtained from the firm of Hartley Wood in Sunderland, the only place in the country where antique, hand-blown glass which has a rippling effect when seen against the light was made. The Commission also agreed to cover the cost of the structure from which the window is suspended, designed by their engineer Jim Pennell. The original idea had been to suspend the window between two trees, but this proved to be impractical owing to the weight of the window and the shallow roots of the Douglas fir trees.

The subject of the window is the forest itself, a picture within a picture. Its design is based on drawings made by the artist during a week of research in the forest, finding the site and making studies of trees and vegetation. The style of the stained glass is neither medieval nor modern, but in the manner of the decorative stained glass of the 1920's and 30's. The window was made by Glass Distinction to Atherton's detailed drawings, and the metal frame was interleaved with polycarbonate sheets for basic protection. As Atherton has remarked, the window is not primarily about the art of stained glass, but about the idea of the forest as a Cathedral, with its sense of sanctity and quiet, a refuge from the busy world, a place like Tintern Abbey nearby, for the contemplation of God's grandeur.

Peter Appleton's sculpture, *Melissa's Swing*, named after his daughter, was conceived as a kind of Aeolian Harp to be suspended in a tree for the wind to activate into sound. Since the wind is less noticeable in summer when most people would visit the sculptures, he felt that people should be able to make the sound for themselves, by pulling on an attached rope. Since they were bound to swing on the rope, he thought it best to complete the piece with a swing, so that people could enjoy the sensation of swinging while the shimmering metallic sounds filtered in and out of the natural sounds of the forest. When softly stirred the sound is like that of the wind in the leaves, but when vigorously shaken, it resembles the sound of thunder. The sculpture alerts us to the many different and subtle sounds of the forest, so that our sense of hearing as well as our sense of sight and touch is stimulated. You walk away from the swing more aware of the insect sounds, the birdsong, the breeze stirring the leaves, the rustle of a snake in the undergrowth, the ripple of water, or the whine of a chainsaw in the distance.

*Peter Appleton*, Melissa's Swing, *1986, galvanised steel, wood.*

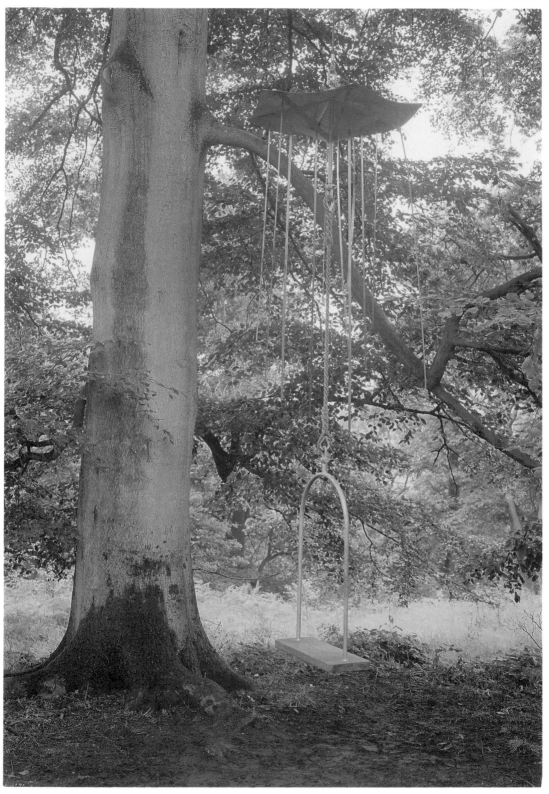

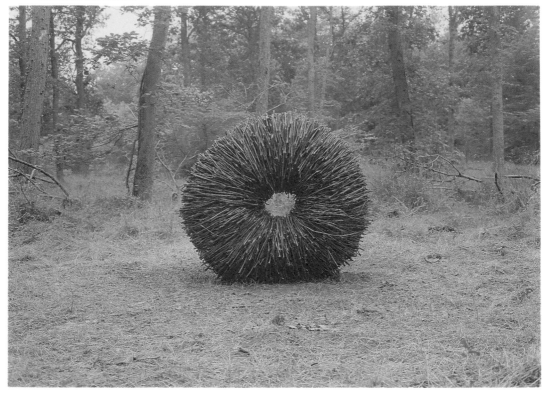

During his subsequent two month residency, Peter Appleton was able to realise his idea of a musical work which responded to the wind. *Wind Chimes*, situated near the stained glass window, is a cross-section of a pine trunk with six branches sticking out, placed on a 10 foot pole. Three sails alternate with three bell-shapes of different sizes to give different notes. The chiming of these bells has a pleasing irregularity, creating a continually changing harmony in the breeze. The bell shapes derived from metal containers being made for an ephemeral sculpture that only lasted one year, *Nine Evening Fireflies,* which consisted of tiny battery-powered red lights which flickered on and off to suggest the insect life of the forest.

Two other artists-in-residence created works of equal subtlety and fragility. By spending several months in the forest they were able to observe the minutiae of forest life, to discover its secluded places and to experiment with materials to hand to create forms that were more ephemeral than the major commissioned works. Stuart Frost's *Bracken Ring* and *Bracken Knot* lasted no more than two summers, changing from bright green to brown before their eventual disintegration. The simple shapes of ring and knot were woven with great skill using a material that is very difficult to handle. Yvette Martin's *Four Seasons* have proved equally vulnerable to the elements, but during the four months of her residency over 8,000 people were able to appreciate the quality of her work and discuss it with her. The woven canopy of branches enclosing an embryonic curve of stones placed in a pond, echoes the shape of the hollowed-out quarry. The branches of surrounding trees have been bent down to create an even more enclosed space, suggestive of the first stirrings of spring in the womb of nature. The subsequent seasons continue the theme of growth, maturity and decay, with the flowering forms of summer, the ripening seed pods of autumn and the skeletal vertebrae of winter. The forest has already begun to reclaim its territory, and the work has almost disappeared.

# INTERLUDE

The first phase opened on Midsummer's Day, 1986. Even after a three year period of gestation, invitation and commissioning, not all the works were ready by then, including *Place* and *Cathedral*, which were completed in July. To complement the works in the Forest and as part of the original concept of involving media other than sculpture, two exhibitions were held at the Arnolfini, Bristol. The first, selected by art critic Lynne Cooke, on the theme of *The Forest*, included paintings and sculpture by artists from England,

*Stuart Frost*, Bracken Ring, *1986, bracken.*

Denmark, Poland, Italy and America, whilst the second consisted of the photographs of the Forest of Dean by Keith Arnatt and Fay Godwin, commissioned for the project. Keith Arnatt's cool and classical observations of the no-man's land on the edge of the forest, entitled *The Eaves of the Forest*, contrasted with the more Romantic interpretation of the forest by Fay Godwin, the publication of whose book, *The Secret Forest of Dean,* containing interviews with Foresters and poems by Geoffrey Hill and Charles Tomlinson among others, coincided with the launch of the project.

During the summer, twenty workshops took place in the forest for both children and adults, who produced a number of imaginative works inspired by the existing sculptures. The residencies of Stuart Frost, Peter Appleton and Yvette Martin also helped to generate interest in the work. Throughout the next year the teething problems over the signposting of the route were sorted out, and in spring 1987, a colour leaflet and map were produced. There was some debate about how much the works should be signposted, but after visitors expressed dismay at not being able to find *all* the sculptures, the route was marked with blue posts. The works themselves were not labelled, as it would have given the impression that the project was an exhibition, and the sculptures merely museum pieces, instead of being charged with the mystery of anonymity. Lack of preconceptions was a vital element in the positive response that the works engendered. In spite of the publicity, many people still thought that the project was a temporary one, and although some of the works were of an epic scale, it was felt that there was scope for further work to be commissioned as part of a second, concluding phase.

This phase was co-ordinated by Art Landmarks, and the concept was focussed on commissioning works that employed materials that were indigenous to the forest, but which had not been used in the first phase, when wood was the predominant material used. Apart from timber, the industries of the forest included the excavation of coal, stone and iron ore, and it seemed appropriate to concentrate on those materials of stone and iron which are common to sculpture. As well as the Forestry Commission continuing their commitment, the funding bodies who had supported the first phase—The Elephant Trust, The Henry Moore Foundation, The Carnegie United Kingdom Trust and South West Arts—made further valuable contributions to the second phase, and additional support was also received from Gloucester County Council, the English Tourist Board, the Ernest Cook Trust, and the Forest of Dean District Council.

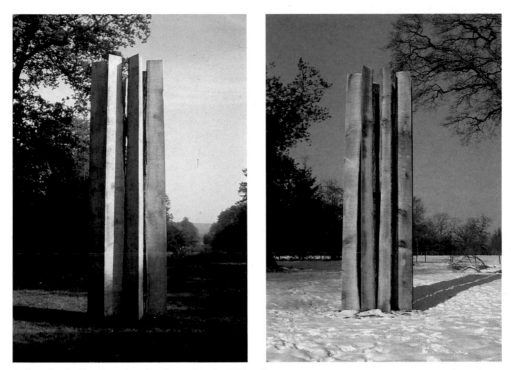

*Andrew Darke,* Sliced Log Star (Inside-out Piece), 1985, oak

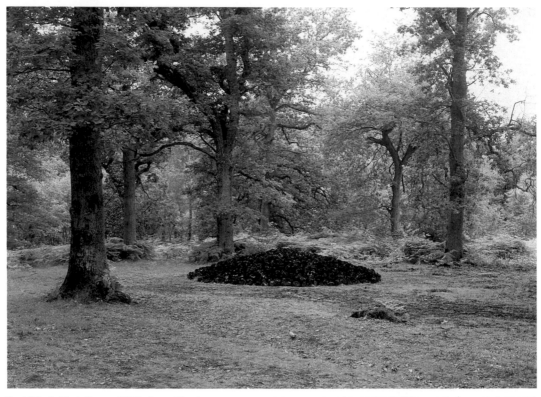

*David Nash*, Black Dome, *1986, charred larch*

*David Nash*, Fire and Water Boats, *1986, charred oak*

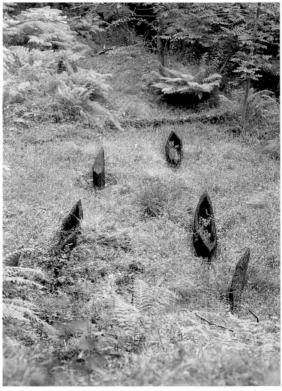

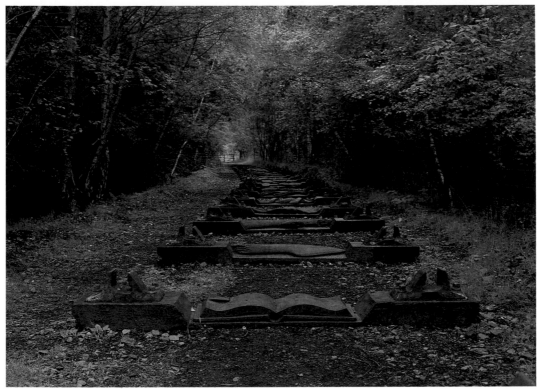

*Keir Smith,* The Iron Road, *1985–6, jarrah wood*

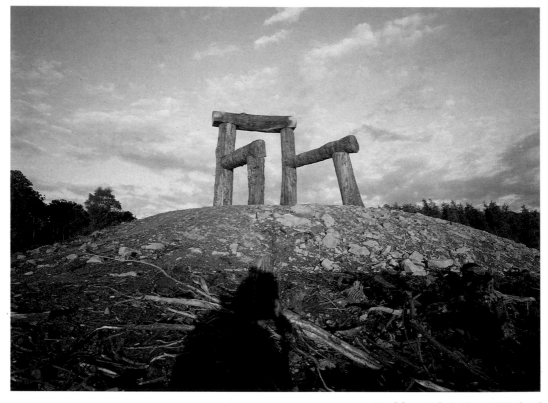

*Magdalena Jetelovà*, Place, *1985–6, oak*

*Kevin Atherton*, Cathedral, *1985–6, stained glass*

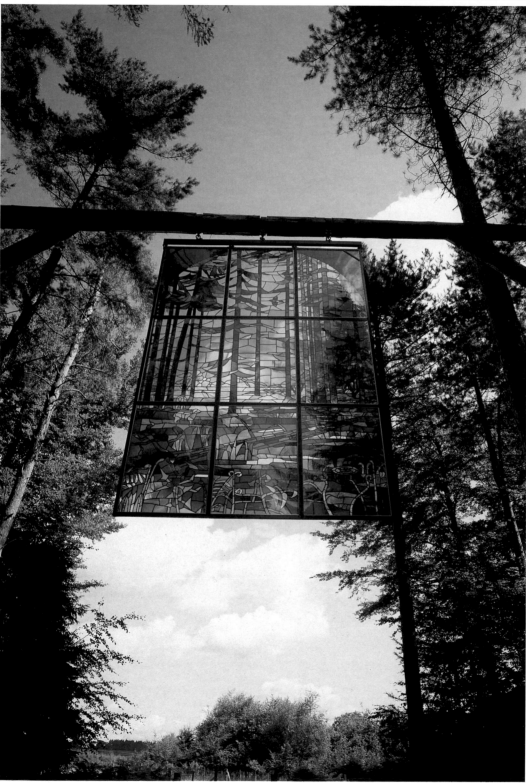

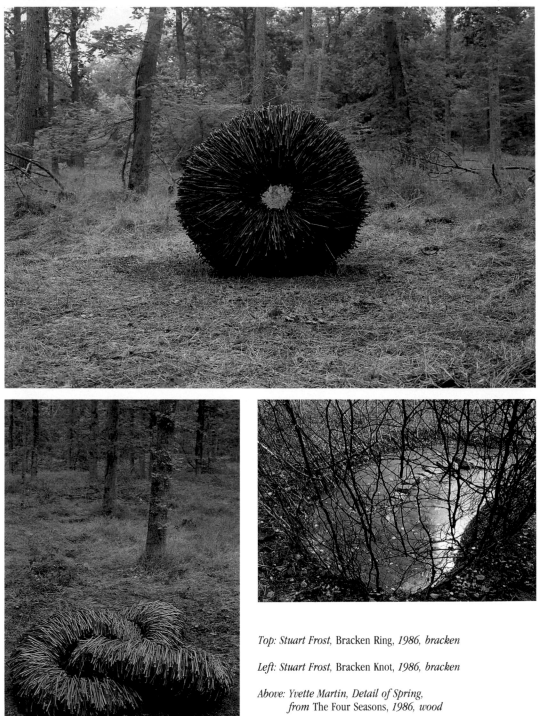

*Top: Stuart Frost,* Bracken Ring, *1986, bracken*

*Left: Stuart Frost,* Bracken Knot, *1986, bracken*

*Above: Yvette Martin, Detail of Spring,*
*from* The Four Seasons, *1986, wood*

*Opposite: Peter Appleton,* Melissa's Swing, *1986,*
*galvanised steel, wood*

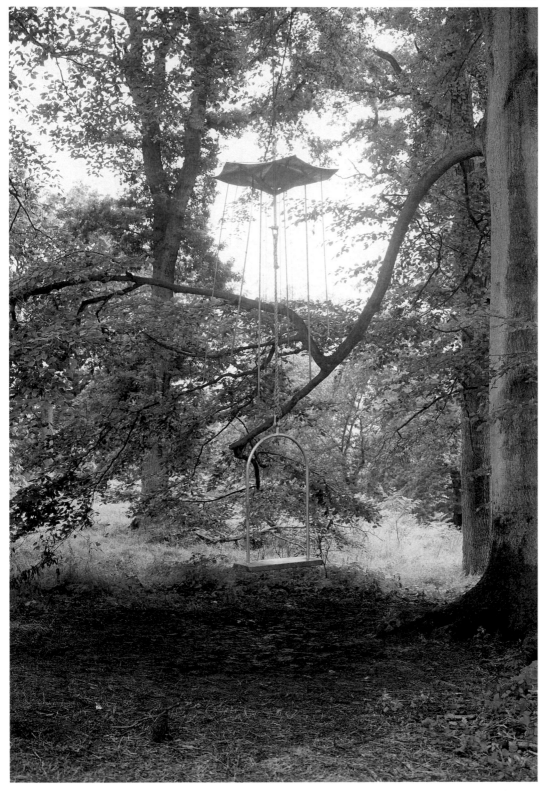

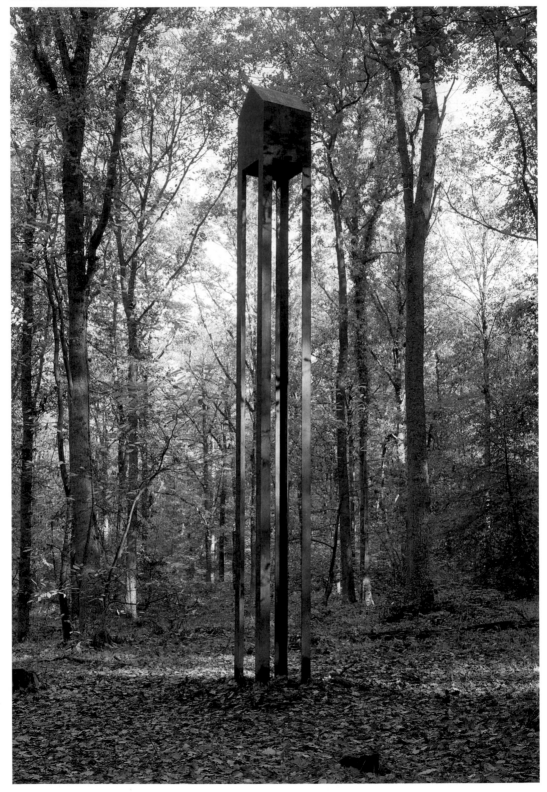

One of the tenets of Surrealism is that a familiar object can be made to appear disconcerting and strange when seen out of its usual context. To come across common domestic objects—a chair, window, staircase or house—in the middle of a forest can be a shock. Divorced as they are from their usual function, and with their scale changed, the objects begin to take on other meanings, while retaining the simplicity of form that acts as a counterpoint to the variegated forest. In the first phase, the chair-like structure of Magdalena Jetelovà, and the stained glass window of Kevin Atherton brought a mythic and sacred dimension to our perception of the Forest, as well as having a surreal incongruity.

In the second phase Miles Davies, Bruce Allan and Peter Randall-Page created an Alice in Wonderland world by enlarging or contracting simple forms of a house and staircase, pine cone and acorn cup. The tall, elongated structure which Miles Davies has entitled *House* is neither functional as shelter nor homely in appearance. It suggests the solitude of being in a forest, and the scale of the trees which dwarf if. With its elongated shape, it echoes the tree trunks and also the man-made constructions used in the mining process. The structure is almost invisible and causes one to look up into the roof of the forest, its stillness accentuating the slight movement of the surrounding trees. This enigmatic presence is a serene and harmonious one, even when people treat it like a musical instrument or tuning fork.

Bruce Allan's *Observatory* is equally restrained and simple in form, based on the shape of the early astronomical observatories to be found in India. Apart from the incongruity of finding a staircase that leads nowhere, the observatory is a place from which to observe the forest. Situated beside a small triangular shaped pond, it enables one to look at the trees reflected in its surface. Being at the level of the branches also gives one a different perspective of the forest. *Observatory* has the effect of giving one pause for thought, and the opportunity to contemplate the tranquillity of wood and pond. This experience is further enhanced by a niche at the front with a seat in it. From this position, the trees and pond are framed by the black painted portals, and look bright and luminous, much as it would appear on coming out of a coal mine shaft—a thought confirmed by two former miners who visited the sculpture and spoke to the artist. By painting the structure black, the artist has made a self-effacing work which does not draw attention to itself, but rather to its surroundings. (It is worth noting how several artists, including David Nash and Zadok Ben David, have employed black as a neutral contrast to the green foliage.) The peacefulness of the surroundings has to some extent been compromised by the placing of Sophie Ryder's deer nearby, which attracts many visitors, but the contrast between the animation of the deer crossing the water, and the stillness of *Observatory* is also effective.

*Miles Davies*, House, *1988, steel*                                                                          41

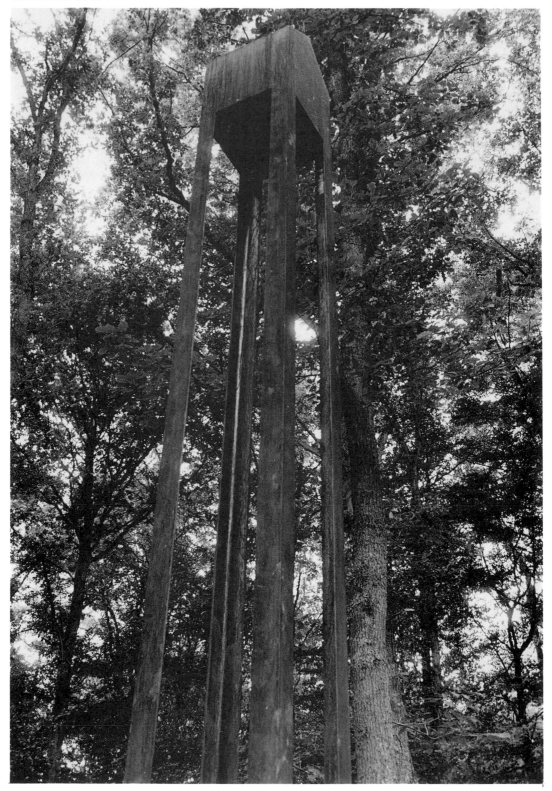

*Bruce Allan*, Observatory, *1988, wood.*

*Miles Davies*, House, *1988, steel.*

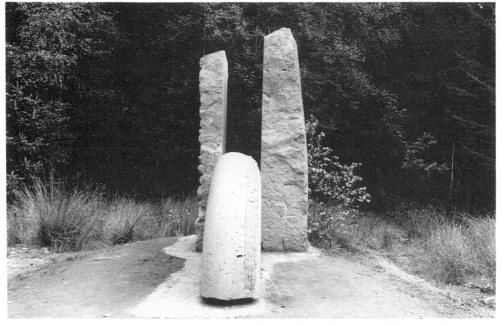

*Tim Lees,* Heart of the Stone, *1988, Forest of Dean stone.*

As with Davies and Allan, Tim Lees also alludes in his work, *Heart of the Stone,* to the idea of mining or cutting into the earth to extract material for man's use. On the site of a disused drift mine, part of the Rose in Hand complex, he has placed a large slab of stone quarried nearby from Robert Taynton's quarry at Bixslade. The central core of the stone has been cut out and placed on the ground, before being honed to a smooth curve. Into this surface he has cut a hole like a hollowed-out cavern. The artist enables us to explore the different textures of the stone from the rough, iron-stained exterior to the smooth finish of the central section. What is essentially an abstract work of art, relying on form and texture, does however also have a figurative dimension, with the hollowed-out cavity suggesting the eye of a fish. Although this may not have been the artist's intention, it is not inappropriate, given the situation of the Dean between two rivers, the Severn and the Wye, well-known for their salmon and elvers. The fish leaping out of the stone could also suggest new life being born out of the remains of the old, the idea of regeneration which is an essential part of the life cycle of the forest.

Another stone-carver, Peter Randall-Page, took as the basis for his works, *Cone* and *Vessel,* the intricate forms of a pine cone and acorn cup. By enlarging the scale so significantly, the object takes on a surreal dimension, suggesting giant forest trees. The skilful carving of the fletched acorn cup and the delicate double spiral of the knobs of the cone draw our attention to the intricate beauty of tiny things, so that our perception of the vast forest is transformed, and we begin to notice the minutiae of the forest life, the curious

*Drawings from Tim Lees's sketchbook, showing the evolution of ideas for his sculpture,* Heart of the Stone.

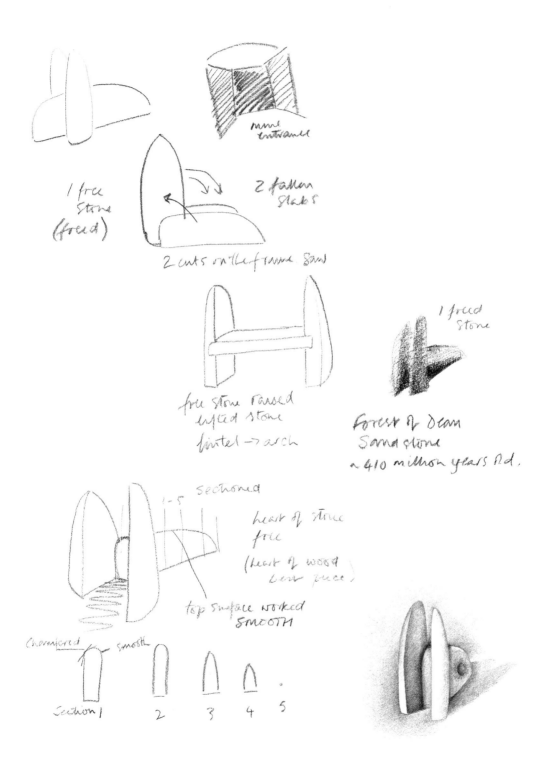

mine
entrance

1 free
stone
(freed)

2 fallen
Slabs

2 cuts on the front Saw

free stone raised
lifted stone
lintel → arch

1 freed
stone

Forest of Dean
Sand stone
~ 410 million years old.

sectioned
1—5

heart of stone
free
(heart of wood
bent piece)

top surface worked
SMOOTH

chamfered      smooth

Section 1      2      3      4      5

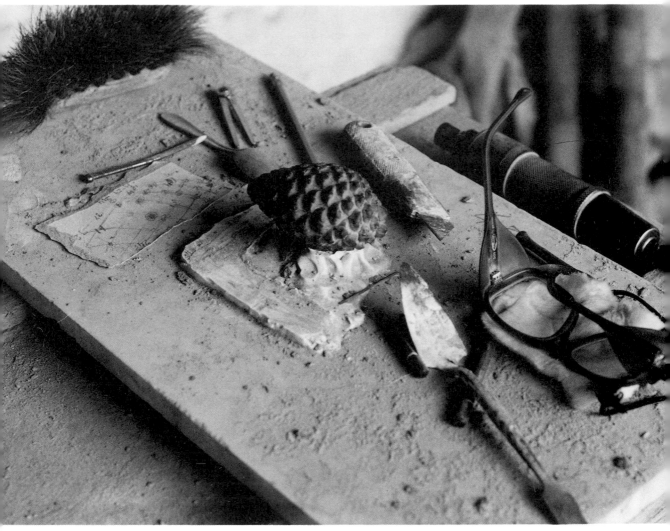

*Pine cone used as maquette for Peter Randall-Page's sculpture,* Cone.

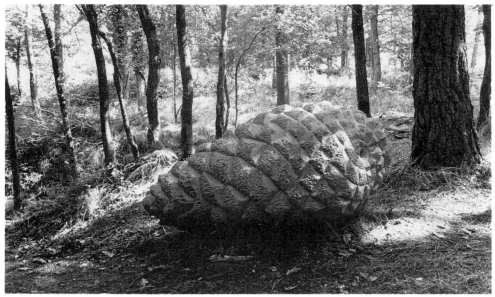

*Peter Randall-Page,* Cone, *1988, Forest of Dean stone.*

configurations of tree bole and leaf, insect and bark, lichen and furled bracken which comprise the hidden face of the forest. From being overawed by the scale of the forest, seen from the sculpture, *Place*, one is drawn into communion with a world of delicate patterns and textures. Each work is placed beneath its appropriate tree in a secluded part of the forest cut off by a deep gully from the routine process of thinning. The place is an isolated piece of woodland, where natural regeneration has taken place, and where a mixture of different species of trees can be found. The area adjoins a siding to the main line which the artist discovered when he was moving the works to their final site, and which greatly facilitated the installation. Nearby the hollowed shapes of the land, dug for stone or coal, echo the convex and concave forms of the sculptures which complement one another, and which represent the balance in the Dean between coniferous and deciduous trees.

It is significant that the artists have not chosen to make a human figure, as if the human element would have been an intrusion. Even the figure proposed by Antony Gormley would not have been sited in the open air. His intriguing idea which ultimately proved too difficult to carry out was to make a figure in cast iron, and to place it in an underground cavern from which iron ore had been excavated, a process of refining and returning the metal to its place of origin in the womb of the earth. There are, however, two small figures contained in the sculpture of Zadok Ben David, which puts the human presence in perspective, by suggesting that they are only apparent in the consciousness of the deer, who preceded man in their habitation of the land. Zadok Ben David's deer are made as if in silhouette, and remind one of the animals inscribed on the walls of the caves at Lascaux inhabited by Cro-

Magnon man. They are drawn in two dimensions rather than realised fully in three dimensions, to suggest the fleeting glimpses that we have of this secretive creature, whose progress through the forest can often only be observed in the footprints which it leaves in the earth. The deer have always occupied a central place in the life of the Dean, being hunted by the kings who laid claim to the forests of England for this purpose. Zadok Ben David has wittily called the piece *As there is no hunting tomorrow* to suggest a holiday freedom for the deer.

Zadok Ben David's deer are not literal representations but creatures of the imagination, suggesting the mysterious, unseen life of the forest. The objects that emanate from them are like the subjects of their dreams, or the simple thoughts they have as they make their carefree way through the forest. Bird, fish, lizard, flower, tree are emblems of the world which the deer inhabit, sculpted in round forms and bright colours to indicate the vividness of their reality compared to the leaner forms of the deer themselves, and the even more insubstantial figures of man. Zadok Ben David's work is the stuff of fairy tale with all its illogicality and fantasy. He was born in the Yemen from a family of silversmiths, and there is a filigree fineness to his work, a desire to contrast the neutral earth colours with a jewel-like brilliance of colour. This contrast of muted and fluorescent colour reflects the different worlds of reality and imagination, and also the cultures of the Middle East and England within which the artist has worked. His work has a nomadic, restless character, which accords with the quicksilver nature of the animals he depicts.

Sophie Ryder draws her inspiration from the English tradition of animal art, with its attention to anatomical correctness. Her subject is the animal itself, not what it might symbolise, and her approach is simple and uncomplicated, deriving from her observation and love of animals. Where her work is unusual is in its use of metal wire to create the illusion of sinew and bone. It is a surprisingly versatile material, and the way the light falls on it suggests the vigorous working of the muscles. Her work is the quintessence of Englishness, and it relates well to the landscape of the Dean. One of the reasons for siting her work in water is the problems she has encountered with people thinking that her sculpture is more solid than it looks, and damaging it by sitting or leaning on it. In this piece she makes a virtue out of the need to protect the work, by placing it in or near the water, where the stillness of the water and the reflections enhance the sense of movement.

*Peter Randall-Page*, Vessel *and* Cone, *1988, Forest of Dean stone*

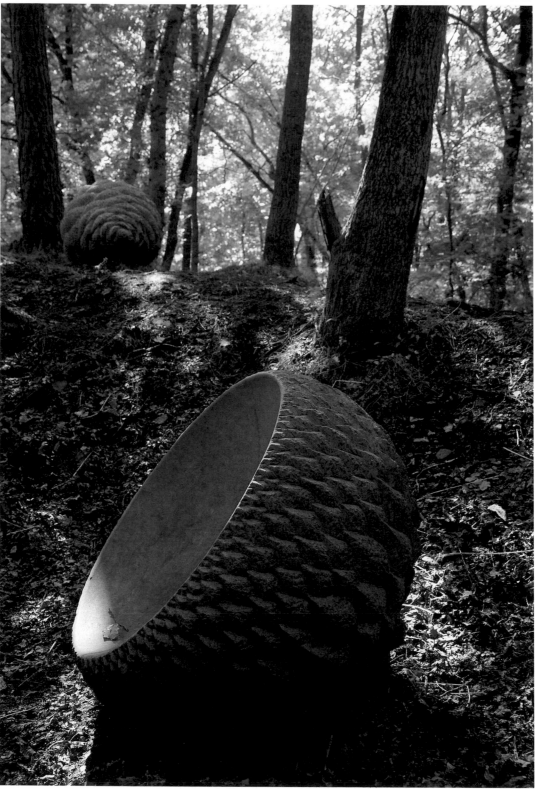

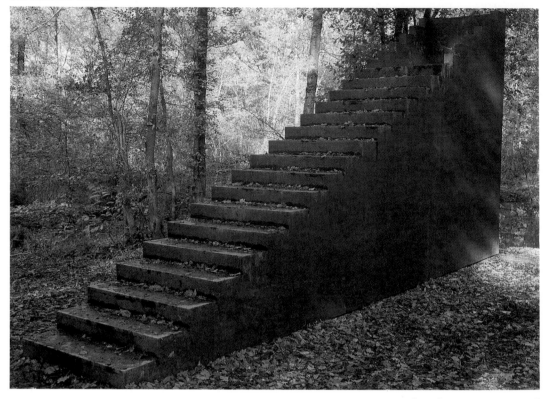

*Bruce Allan,* Observatory, *1988, wood.*

*Tim Lees,* Heart of the Stone, *1988, Forest of Dean stone*

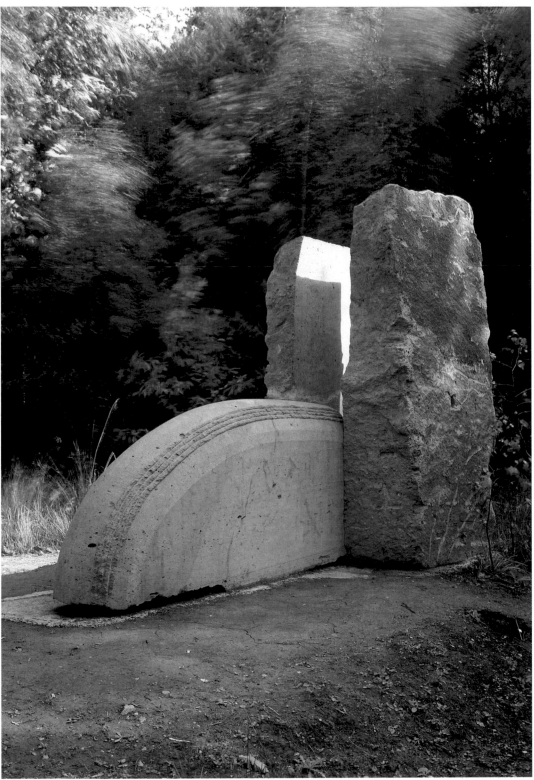

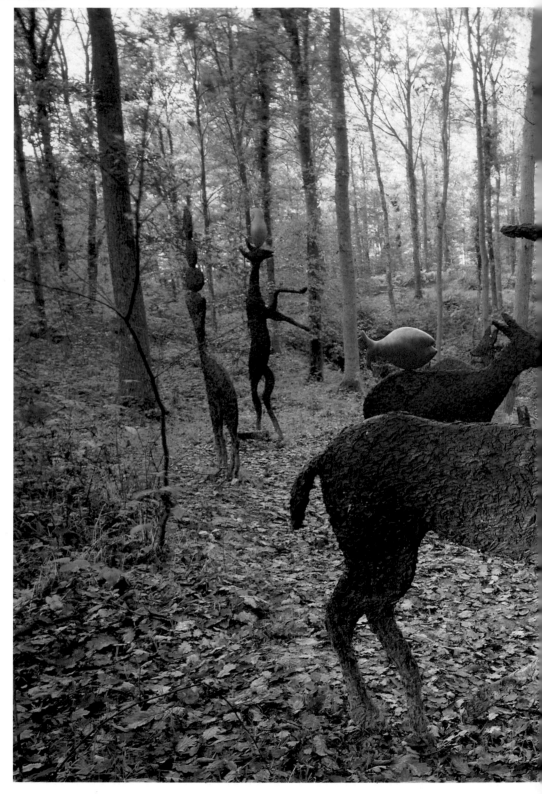

*Zadok Ben David,* As there is no hunting tomorrow, *1988, mixed media*

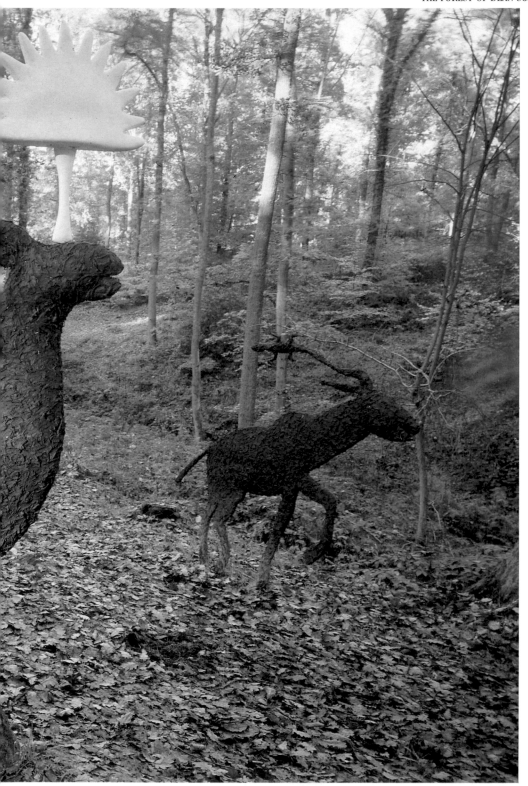

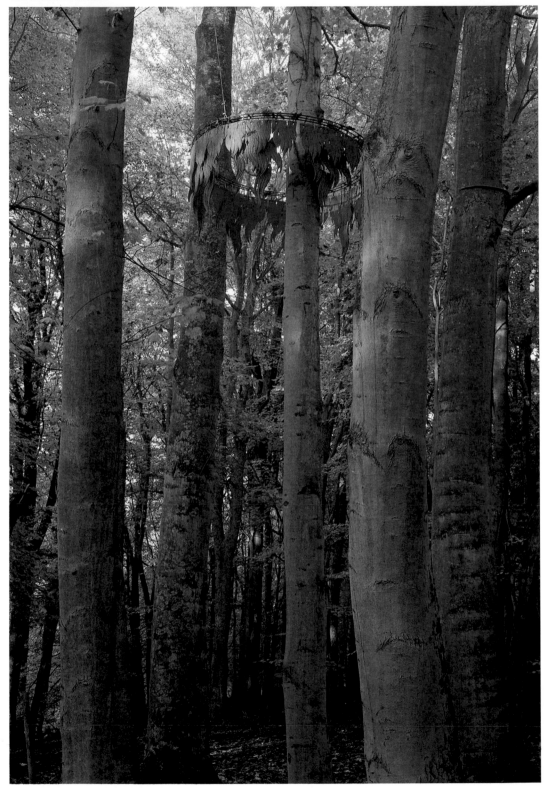

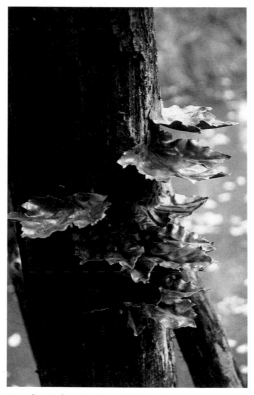

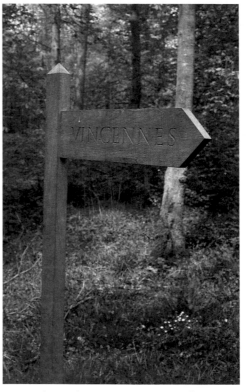

*Cornelia Parker,* Brackets, *1988, lead*

*Ian Hamilton Finlay,* Vincennes, *1988, wood*

*Cornelia Parker,* Hanging Fire, *1988, cast iron*

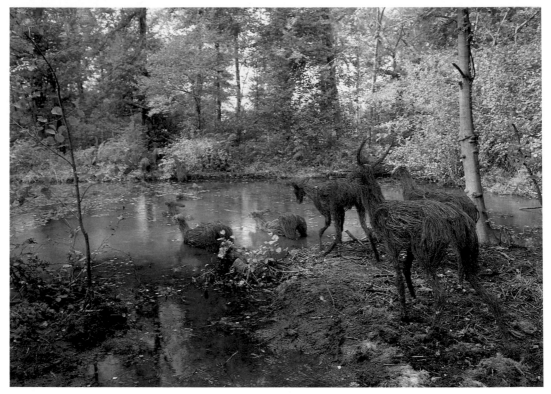

*Sophie Ryder,* River Crossing, *1988, steel wire*

Cornelia Parker's *Hanging Fire* is equally inaccessible, suspended halfway between the earth and the crowns of five sycamore trees growing in a circle. The ring of cast-iron flames hangs upside down and encircles a sixth tree in the middle. Drawing on the symbolism of the crown, the work relates to the royal nature of the forest, and the idea of the fall of kings. It also resembles a crown of thorns while the flames falling from above recall the Holy Spirit at Pentecost, their rust colour reminding one of the leaves falling in autumn. With its various layers of meaning, and with its combination of stillness and implied movement, the crown of flames becomes an emblem of the forest as a sanctuary. The flames were made in cast iron as a way of drawing attention to the iron once embedded in the forest, and were cast in the Cannop Foundry, about three miles away in Cinderford.

Nearby is a piece made during her residency which elaborates on the theme of *Falling Crowns.* Nine crowns, each one wreathed with a circlet of different leaves cut out of copper, now oxidised to a green colour, appear to be tumbling through the tree. Parker's work has a commemorative character rather than one of celebration, and strikes a similar elegiac note to Keir Smith's work. Her small, unobtrusive work entitled *Brackets,* relates to the Bracket fungi which grow on the dead stumps of trees. The lead leaves are affixed to two dead tree trunks in a small pond, near some bracket fungi whose shapes they echo.

The final work to be placed in the forest, entitled *Silence,* provides a fitting epilogue to the Project. Beginning as a writer and concrete poet, Finlay has evolved a language based on neo-classical sculpture and inscription, often sited in the landscape. His garden at Stonypath in Scotland is an example of the fusion of art and nature, and has been the seed-bed for work placed in outdoor sites in Europe such as the *Sacred Grove* at the Kröller-Müller Museum, Otterloo, and the Domaine de Kerguéhennec in Brittany. For the Forest of Dean he extended his concept of the one-word poem, by proposing three plaques with the word 'silence' in different languages, Silence (French, English), Schweigen (German) and Silenzio (Italian). The different languages enable us to appreciate the onomatopoeic character of the word. The tree plaques focus our attention not just on the individual trees on which they are placed, but point to the veil of silence in the forest, pierced by the sounds of birds and insects. Like many other works in the forest they allow us time for recollection and reverie.

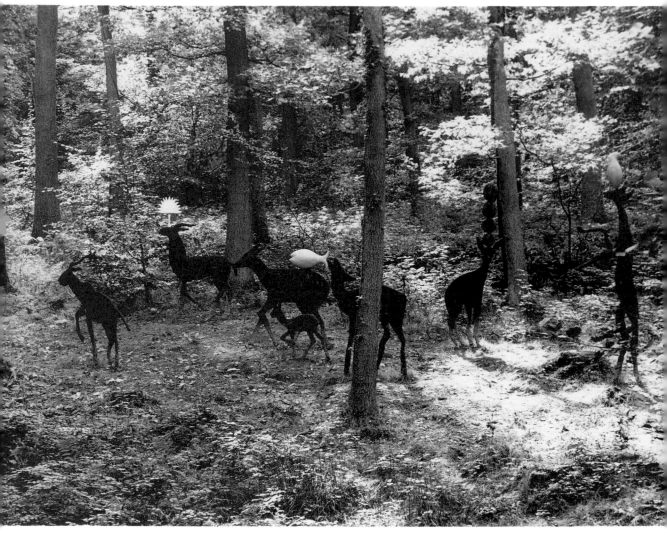

*Zadok Ben David*, As there is no hunting tomorrow, *1988, mixed media.*

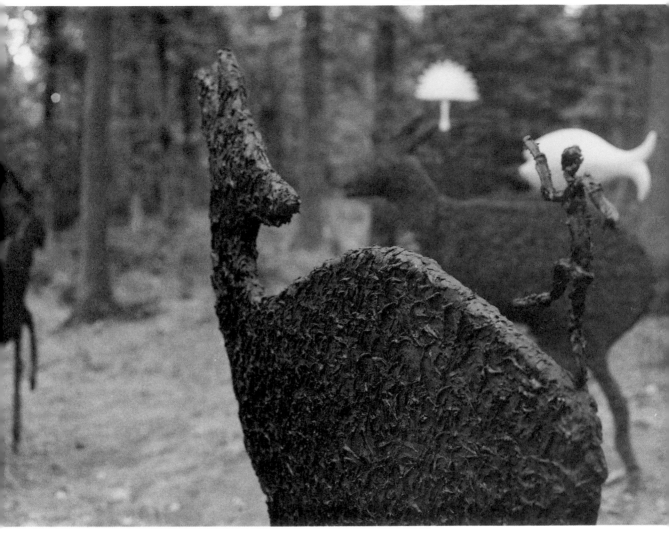

*Detail showing one of the deer in Zadok Ben David's sculpture,*
As there is no hunting tomorrow.

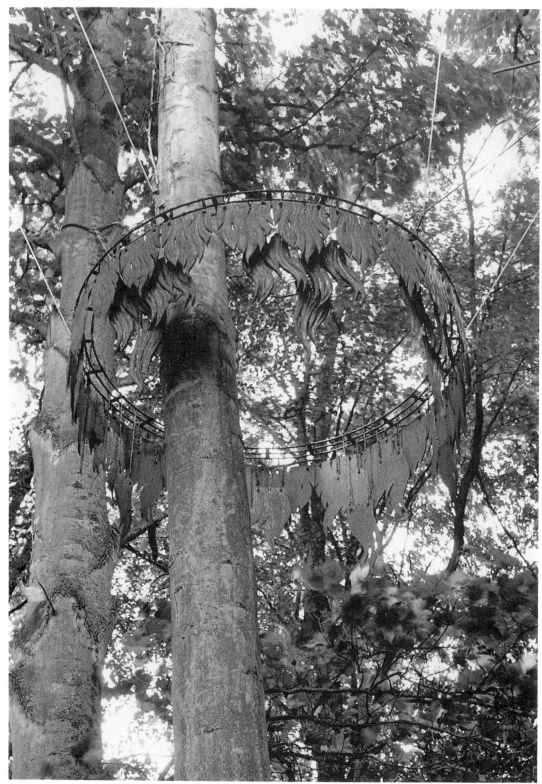

The tree plaques, carved by Nicholas Sloan, and sited by the artist's wife Sue Finlay, are examples of the way in which Finlay works through collaboration with others, to realise his ideas and locate them in the landscape. A second work made in collaboration with Michael Harvey consists of a wooden signpost engraved with the word *Vincennes,* and recalls a Damascus Road revelation experienced by Jean-Jaques Rousseau on the road from Paris to Vincennes in the summer of 1749. In his *Confessions,* Rousseau writes how as he walked and read the newspaper he "came to the following question, proposed by the Academy of Dijon, for the Prize of the ensuing year: 'Has the restoration of the arts and sciences had a purifying effect upon morals?' The moment I had read this I seemed to behold another world and become a different man." The signpost placed incongruously in the Forest of Dean points to Vincennes, and acts as a catalyst for us to consider not only Rousseau's experience, but also the idea of the purifying and redemptive power of art.

Nothing is permanent in the forest, and these artistic interventions are no more than the latest marks left by man on the land. From the first excavations, the forest has been inscribed with lines of passage—paths, railways and watercourses; dug into and sculpted by mines; or cut down and replanted along avenues and in well-defined plots. The different kinds of marks still to be found are like the lines on a face which convey the character of a person. The works of art recently made add another, imaginative dimension to the existing landmarks, and provide food for thought, an archaeology for the soul to explore, as well as a way into the forest. No sculpture can hope to compete with God's sculpture, the trees themselves, and yet the work of artists helps us to see the shapes and contours of the landscape which already exist, and to be more sensitive to the environment we tramp through, often oblivious to its beauty. The sculptures also point to the interior life of the forest; the hidden deer, the sealed-off mines, the disused railways, the tiny cones, the streams which provide a continuous source of music beside many of the sculptures. Although much of the forest is still cropped for timber, the Cannop Valley with its predominance of oak retains much of the character of the forest that Pepys visited to check on the resources of oak available for the Navy, and whose timber he found to be 'exceeding good'. The valley has now taken on a new lease of life with its designation as a National Nature Reserve, and the sculptures have become a part of the regeneration of the forest and forest life which is taking place in the Dean today.

*Cornelia Parker,* Hanging Fire, *1988, cast iron.*

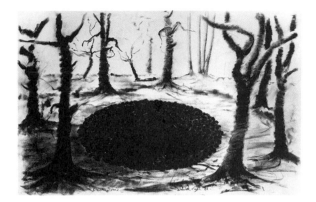

ARTISTS' STATEMENTS

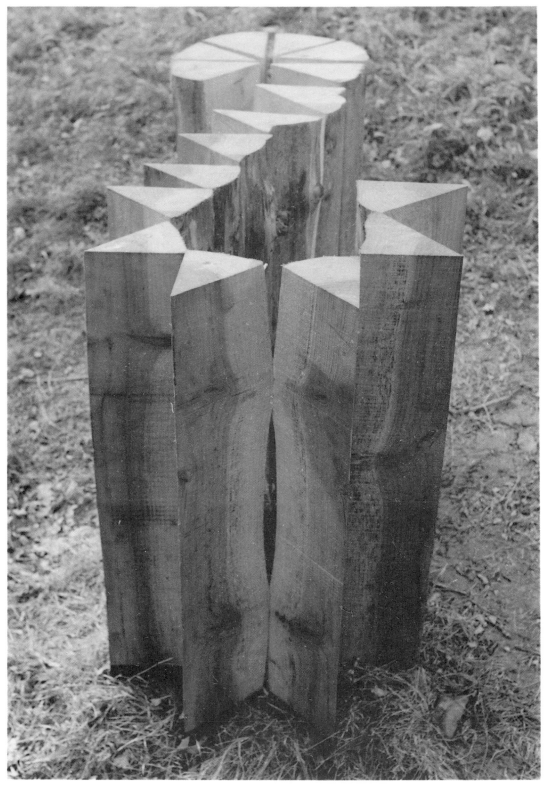

# ANDREW DARKE
## Sliced Log Star

At the first meeting of artists with Rupert Martin and Martin Orrom some of us pressed the latter for a brief. He suggested that we should somehow *re-interpret* the forest. I was stimulated by the sheer size of the tree community here—a totally different experience from the spare and relatively treeless landscapes of Yorkshire where I had lived up to then.

I made two proposals and the one chosen, *Sliced Log Star*, was a new work in my Sliced Log series. I wanted to expose the life-growth history of the tree and at the same time, by siting the work near a tree of the same species and similar age, show how such a rough, venerable and craggy creature contains a cylinder of beautiful material. A further aspect of the siting was crucial. By placing the work at the end of Spruce Ride I could draw attention to the monumental aspect of a tree, so the sculpture works much as an obelisk placed at the end of a vista in the grounds of a stately home. This position at the end of Spruce Ride and within the boundary of the Speech House Arboretum also satisfied my wish not to impose upon the forest proper. The work also encloses an inaccessible space in the centre equivalent in volume to the original log. The second work standing nearby is small enough for children to be able to look down upon and see the "unwrapping" process that the main work has undergone.

On the technical side the critical process in the work was the cutting of the log into eight segments. The sawmill was hired for a Saturday morning and when I arrived and explained what I wanted to the sawyer he assured me it would *not* be possible. Four hours later, with eight beautiful segments lying on the rollers, the now smiling Welsh sawyer shook my hand and said how much he had enjoyed the morning's work and he hadn't thought the machinery would be capable of producing wood with a triangular cross section.

Living in the Forest does give the opportunity to hear the reactions of local people. Criticism seems to revolve round two main points. Firstly, is the work an intrusion in the forest? This is unresolvable but everyone agrees that some pieces intrude more than others. Secondly, there is a feeling that the project was foisted onto the Foresters and that more could have been done to involve locals. Nevertheless, I think I can honestly say that most reactions are favourable—on the lines that the sculpture is an extra tourist attraction and the Forestry Commission is seen as giving something back to the Forest.

*Andrew Darke, Explanatory Piece, showing how* Sliced Log Star *was made.*

# DAVID NASH
# Black Dome & Fire and Water Boats

While in Grizedale Forest, Cumbria, working as resident sculptor in 1978, I often came across centuries old-charcoal burners' sites—oval level spaces, barely discernible on the hillside, with always the same combination of plants. Presumably the carbon residue from the charcoaling process only allows certain species of plant to flourish. These spaces, although nearly invisible, had a sense of the human being, a presence remaining from the concentrated activity of charcoal burning. The experience of these spaces made a deep impression on me.

The Forest of Dean also has a history of charcoal manufacture. The idea for *Black Dome* arose from these thoughts encouraged by the appropriateness of an object that has an image link with the history of the forest. Ideally the sculpture would be a mound of charcoal, but charcoal having no structure would not have survived the public's use. The sculpture needed to be anchored to survive, so I opted for charring the ends of sharpened larch poles.

Using about a kilometre of larch, Charlie Everett and I charred nine hundred pieces over a two week period. After the first day we had achieved only fifteen pieces. We thought we would be there forever. However, we improved our technique and on the fourth day had increased our daily rate to over a hundred.

The site looked like a Napoleonic gun emplacement. In fact, the oaks around us were planted by request of the British Navy during the Napoleonic Wars (Nelson Oaks), in preparation to build the fleet of the mid-twentieth century. The shipbuilders of 1800 had run out of oak and had to use teak from India.

This led to thoughts of boats and vessels. A dead oak had been felled for us to use for the charring which also yielded other sculptures to take home, *Stepped Oak Branch* and *Descending Vessel* being among them. From the oak I cut three vessel forms and passed them through the fire (charring also acts as a wood preserver). The resulting pieces were placed in a boggy area in a dell full of wild watercress.

Meanwhile, back at the *Black Dome,* the Forestry Commission had hired a machine to dig a hole, twenty five feet in diameter and eighteen inches deep, partly filled with gravel for drainage. The nine hundred stakes were graded to form a dome, each ring being wired together to prevent pieces being pulled out. The spaces between stakes were filled with gravel.

I envisage the sculpture gradually re-integrating with its environment, rotting down gradually—fungus, leaf-mould, plants adding to its progress of 'return'—leaving eventually a vestige of the original form, a slight hump. Rather than make an object that resists the elements of nature, I try to find ways of engaging those elements so the object is continually active in the environment. What I had not envisaged was visitors' desire to walk over the dome, and by so doing polishing it. On a recent visit it seemed like a stroked cat. It will be interesting to see how this added element affects the re-integration.

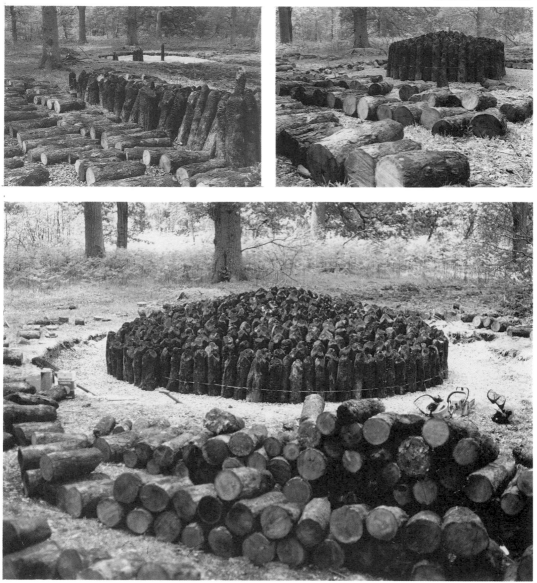

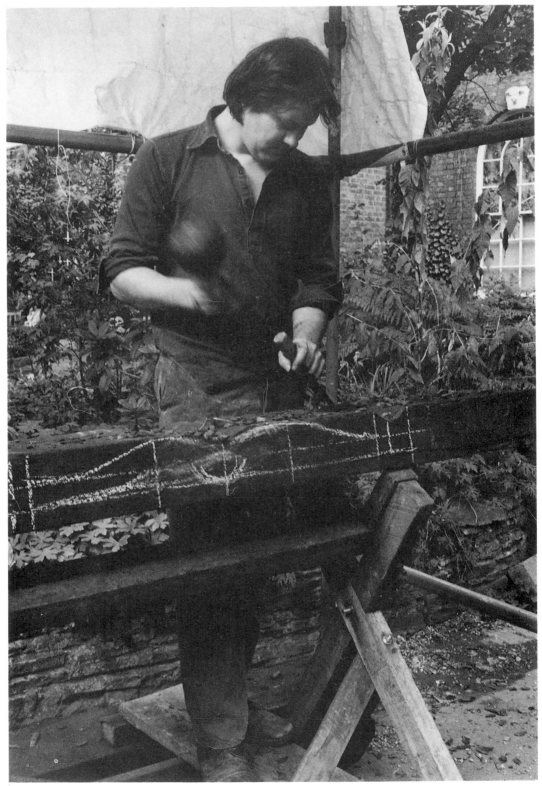

# KEIR SMITH
# The Iron Road

The *Iron Road* was installed along a stretch of disused railway embankment deep in the Forest. The site was entirely appropriate to the spirit of the sculpture; more than any other work it achieved my ambition to blur the boundaries between site and sculpture, to allow resonances from the work to extend far out into the host landscape.

The *Iron Road* is composed of twenty carved units. Only the central section of each sleeper is used, the end sections are left intact and carry the cast-iron 'chairs' which once supported the track. Thematically the carved images range from those associated with the site itself to obsessional images which repeatedly force themselves into my work. One such image is the feather. Feathers open and close the *Iron Road*, the beginning of the track depicts a broad feather fallen from the sky, lying awkwardly on the ground, heavy and useless: a hundred feet further down the line the sequence ends with a redeemed feather, carried through the air on a cloud, returned to its native element. Between these framing devices, images group themselves into zones, a zone of single objects, a zone of fire and smoke and finally a zone of clouds. Some images occur in different guises throughout the *Iron Road*. An opened carved book, at the beginning of the suite, reappears, smouldering, in the central section with neighbouring incendiary motifs, a flaming wheel, a burning house, a lightning shattered tree. Smoke acts as a transition between the central zone and the clouds depicted in the final group of carvings. In one sculpture a bough torn from the shattered tree depicted near to the beginning of the *Iron Road*, is supported on a vast cumulus and breaks into leaf and bud: once again the idea of redemption is implicit. These sculptures carry a sense of meaning but are not decodable. There is no key which unlocks a precise narrative, the carvings are allusive and finally illusive.

*Keir Smith at work carving one of the twenty railway sleepers for* The Iron Road, *1985.*

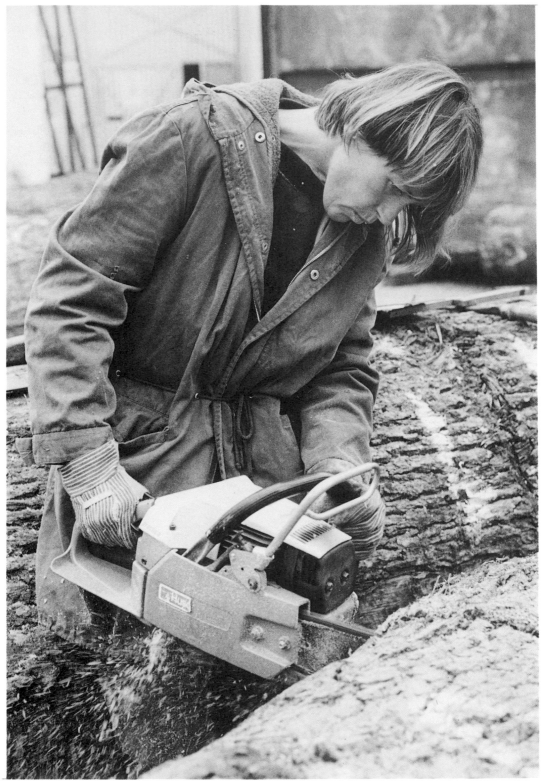

# MAGDALENA JETELOVÀ
## Place

Right from the start I worked with objects, first with a table, then came windows. But I do not make objects, my work is always about something else. What matters is not the object itself but something different from what we see. I am interested in placing a particular sculpture in different environments, into different contexts.

My sculptures go for the basics. I am interested in getting through to the essence, to reach the origins. That is why I am fascinated by the Middle Ages.

I have often thought what a perfect image the cross is. It is a very simple symbol. I am interested in the most basic signs: I want to extract the idea they contain and take it still further.

I do not go for a formal approach. Nothing I produce is made in a formal way. What matters immensely for me is the content. I fill all my sculptures with content. I project life into objects. I project a given situation at a certain time and and in a specific place.

I am talking about changes in reality. Everything has several levels, there are always several possibilities.

*Magdalena Jetelovà at work with chain saw cutting the tenon and mortice joints for* Place, *at Bristol Sculpture Shed.*

# KEVIN ATHERTON
# Cathedral

Although consisting of one large window 15 feet high by 10 feet across, *Cathedral* is not just about itself as an example of the art of stained glass. The undeniably attractive qualities of stained glass are in this instance secondary to the idea of placing the window in the forest. Operating as a visual trigger, the window is intended to serve to connect mentally the concepts of two separate spaces, the 'forest' and the 'cathedral'.

Amongst the common features shared between forest and cathedral is the way that they are affected by natural light. In both cases there exists a darker, interior light, in the spectator's space, surrounded by a brighter, outside light. This is an essential ingredient, fundamental to the viewing of stained glass and, as applied in *Cathedral* means that in order to see the window properly the viewer has to enter into the forest.

Although deliberately using the association between stained glass windows and church architecture, the subject matter of the window is not religious but is a design taken from drawings and paintings done in the forest. The tracery of branches and the stark silhouettes of trees lend themselves very well to the properties of lead line, and similarly the pooling of light on the forest floor transfers naturally to the pure colour of the cut glass shapes.

This means that the forest is the CONTEXT, the window is the FORM, and the image is the CONTENT. It is the inter-relationship between these three that makes the SCULPTURE.

*Statement by artist, 1986*

———————

"The image in the window is not a literal representation of this location, it's a culmination of drawings and photographs I did around the forest. It does key into where it is—the morning window faces east, the pool of bright yellow light reflects that, whilst the window originally intended to face west was an evening window, with a more mellow and longer light.

Where we are has been planted; the forest is a man-made environment, it's certainly managed in a very controlled and disciplined, sectioned-off, logical and geometric way. That's the kind of thing that gives it a grip for me. It's quite an aggresssive piece, it is unsympathetic to nature, but in a way I think that, in order for it to say something, it has to be that aggressive against it. It has to stand up. The danger with being sympathetic to nature is that the thing ends up looking so much like nature that it's just consumed by nature. You've got to go against the grain, to a degree. I quite like the fact that it's glass which is often associated with an industrial environment. Glass is also a valuable material. It conveys the idea that it's been here a long time. There's an aura about it that's because of the connotations of stained glass.

It always has been here in people's heads, the analogy of the cathedral to the forest. The imagery in the window has just made that thought visible and it draws on the tradition of stained glass that goes back to medieval stained glass, and I like that. But it is also interesting to take this material which is very fragile and to make public art with it."

*From an Interview with Michael Archer for Audio Arts.*

*Laying out the stained glass panels for Kevin Atherton's* Cathedral.

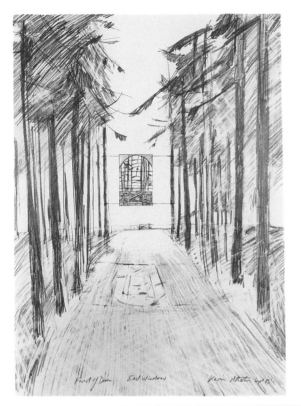

*Kevin Atherton, preliminary drawing for* Cathedral.

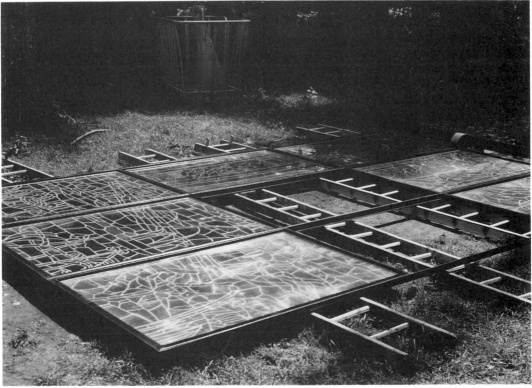

# SOPHIE RYDER
## River Crossing

When I first visited the forest, I knew straight away that I wanted to make a group sculpture. Since I make animals, one solitary form would have been lost in the trees unless it had been very large. The animals that felt right to me were deer. The next hurdle was the site. I had a lot of problems with siting my work outside, as it is very fragile and tempting for children to sit on. The idea that sprung to mind was to situate them in water. There is a lake called Three Islands Lake, and I wanted to make a herd of deer rushing from one island to the next through the water. The site turned out to be a dragonfly sanctuary so that was out. I was set on the idea of water by this stage and eventually we found another pond.

I had one month in which to work. I wanted to make twenty deer, but had time only to make thirteen. The space they occupy is quite large and I still think there could have been more of them, to create more of an atmosphere of this herd of frightened or disturbed animals rushing across the water. I thought I was going to have problems putting them in place and fixing them in the water. I had plans to build a bridge underwater with holes in, and then to place the steel rod frames of the deer's legs into the holes, but

this proved unnecessary. What I did was to make the legs much longer than normal and sink them into the deep mud on the bottom of the pond. Since the water is so still, I am hoping the deer will stay in position for a year or two. The wire I have used is very rusty, so they will rust away before they sink. I love the different shapes in colour and texture of rusting wire.

Julian Davies had a project going nearby with schoolchildren, and when I had finished installing they helped me collect mosses to plant on and around the island, which by now was very muddy. All the trees and shrubs were very lush and green at the time, September/October, and the deer were hidden from many angles.

I went back a few months later to check on them, and was amazed to see most of them exactly as I left them. One had been pushed in, but we managed to rescue it, and one had been sat on. Since it was winter it looked really sparse, and as you could see them from way back, there was no feeling of discovery. They jump straight out at you and look very vulnerable. I called the piece, *River Crossing*, which leaves the onlooker to decide for themselves why they are crossing.

# YVETTE MARTIN
## Four Seasons

The first major discovery about the Forest of Dean, along with its sheer size, was its variety, not only in the type of trees grown, but also in the changes in gradient. Small hills, valleys, grassy glades, thick dark conifer plantations, bare-floored beech areas, and wild unaffected oaklands, punctuated by small ponds, streams and marshland. It took a second visit of four days to even begin to feel I was getting to know the forest.

The ideas grew purely from the experience of being in the forest. The first few days in residence were still needed to carry out more explorations. I wanted to do work that would somehow rewrite all these wonderful variations in a way that might represent 'the forest' as whole. The cycle of life from conception, emergence, growth, reproduction, maturity, decay and death was all around, and it was that inevitable cycle that seemed to epitomise the forest. After I had started the first sculpture and through many discussions with local people about the different seasons, I began to realise the connection of these growth cycles with the changes of the seasons.

The site had to be chosen carefully, as it was also to provide materials, wherever possible. As my project was not going to need more than one site along a path, I was lucky to find the particular sequence of sites used. The first site was slightly secluded, and gave one a feeling of protection. It had a marshy pool with rich, copper-coloured mud, and was protected from all sides by a small cliff face, banks and trees, with a natural enclosed canopy. The second site was very open in comparison, and you felt distinctly exposed. The trees were taller and more sparse and it was very boggy. The third site had good solid ground, with larger, quite dominant trees. It had an almost stage-like feel to it, and the sun lit up the centre. The fourth site by contrast was quite dark, secluded and cool on a mud and leaf-covered bank with a quiet feel. These sites perfectly fitted the sequence of the Four Seasons, with the cycle of life from Spring to Winter, from birth through maturity to death.

# TIM LEES
## Heart of the Stone

I first visited the forest on a beautiful summer's day and was immediately struck by the variety of colours and textures. Ideas poured in. All I had to do was match an idea with a site—a much longer process than I had originally thought possible.

Many wetter visits later in spring, I had come up with an acceptable proposal. I was to use a large piece of Forest of Dean sandstone on the site of an old coal mine; the idea of me labouring away cutting the stone would somehow link me to the miners of old, the Forest of Dean having been mined for many centuries. I wanted to open up the inside of my sculpture, to disembowel it, to show both inside and out. The site mirrored this very well, being fairly enclosed with large trees and yet with an open view through a clearing at one end, and the whole covered with coal slag from the mine.

The stone was kindly selected by Robert Taynton of Mine Train Quarries, the block split into two to reach its present composite size and transported to the saw with a valiant effort by the haulier. The lifting gear on the lorry loaded the block on easily enough but for some unknown reason was not able to lift it off, so a double lift was organised, the lorry's 10 tonne Hiab lifting from the top and a 7 tonne fork lift from the bottom. Once it had been cut into three pieces on the frame-saw a fault was discovered running through all three, one piece eventually completely breaking requiring a large-scale repair job with 25mm thick stainless steel dowels. Finally I was able to start shaping it producing a smooth curve on one face and a series of textured chamfers on the other, the textures directly related to the carving process in producing a smooth curve. I wanted to leave evidence of the carving of the stone in the same way the miners had left their marks on the landscape; a sort of history of the work in the textures similar in sentiment to the imprint of a leaf in mud or the rings of a tree, the rhythms of the seasons being my inspiration. A much older history is apparent in the observation of the flat surface of the stone, the minerals of the stone telling the story of what it was like in the Forest of Dean many millions of years ago.

The stones were positioned on site with the centre section rotated through 90 degrees so that one could stand in the space where it used to be and experience an enclosed sensation, an empathy with the miners. The piece was finally sited with its long axis pointing towards the opening panorama of the forest.

*Tim Lees at work installing* Heart of the Stone.

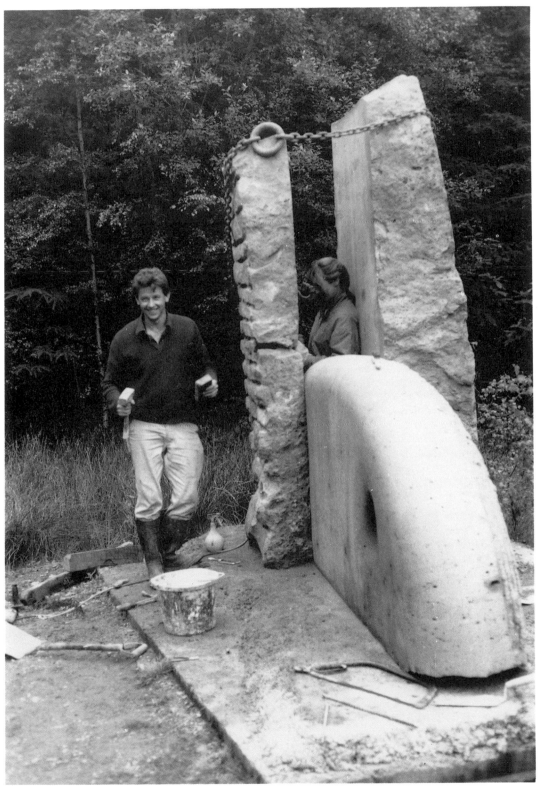

# PETER APPLETON
## Melissa's Swing

For me the forest turned out to be as much about people as trees. I hadn't heard of the Forest of Dean before the possibility of a commission arose, and my first imaginings were of a Robin Hood type habitat—the Robin Hood that people over thirty watched as children. The outlaws turned out to be Freeminers and Sheepbadgers, with the Forestry Commission as the Sheriff, though a little more benign. The hero was Gary Trigg who lives at Kensley Lodge in the heart of the Forest. Gary taught me the difference between yew and beech and also introduced me to old 'Wilf' who brewed cider. Pleasant evenings were· spent on Wilf's bench overlooking Gloucestershire; very few words but a lot of good feelings. The tap was not always open and some art was made.

*Melissa's Swing,* the first piece, was made in my studio in Exeter, and although the materials were foreign to the forest, apart from the wooden seat, the sound seemed to suggest sylvan voices and the wind in the leaves. It wasn't intended as a piece to look at, but as a place to look from.

*Nine Evening Fireflies* was my favourite piece. This consisted of nine tiny red-coloured lights set in a copse of Canadian Spruce trees in a very dark part of the forest opposite the Speech House. They were barely visible during the day, but at night seemed to be alive. Even though I knew that their anatomy consisted of a capacitor, a resistor and an i.c., in the dark I found them awesome. The last time I was in the forest there were still four left, with their batteries having lasted three years. The men who sat on the bench in the Speech House claimed it was the beer that made you see them.

The *Wind Chimes* were the result of finding an interesting object in the forest. The revolving section of tree with six evenly-spaced branches was a bit of waste left after a section of forest had been harvested. The bells were made from scrap metal found at the scrapyard in Cinderford. Its position close to where I stayed in my caravan was important. That area had been harvested before I arrived and the insects I often heard, but never saw, seemed to inhabit the remaining stumps, almost like the spirits of the departed trees. I thought the sculpture had a Tibetan feel and rang for the departed.

*Peter Appleton beside* Melissa's Swing.

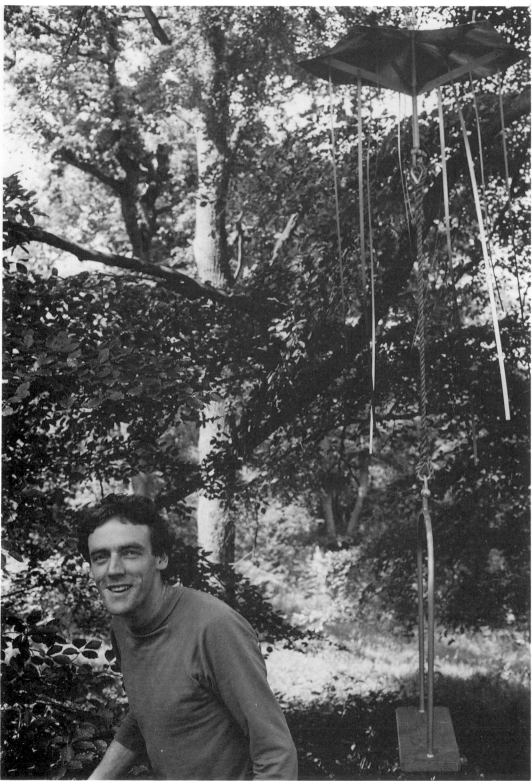

# PETER RANDALL-PAGE
## Cone & Vessel

I had visited the Forest of Dean on several occasions in the past and felt very excited at the prospect of making work to be sited there. My approach to making work for a rural environment is somewhat different from that which I adopt for an urban site. The urban environments in which I have sited work in the past have often been both anonymous and overpowering and I have seen my role as one of humanising these places; introducing elements which refer to organic form and human scale, but are at the same time striking enough to hold their own against the surrounding architecture. In these situations I often see the work as an antidote to the environment—it may be in direct opposition to it—and my approach can be extravagant and extrovert. For me a rural site presents a very different set of problems and priorities, and is in many ways very much more difficult to work with. In the countryside I do not see my work as competing with the environment in the way that it must in the city, and I do not wish to make assertive or bombastic statements which gain their impact through incongruity or confrontation. Instead I see my role as that of re-interpreting elements of the natural environment through a process of distillation and transformation. This transformation is both investigative and celebratory and results from both conscious appreciation and intimate subjective involvement through looking and working.

I decided to base my work for the Forest of Dean on elements found within the forest itself. The seeds of common trees are wondrous things; their extraordinary potential and exquisite beauty. Their familiarity can however stop us really seeing them; we know what they are and our appreciation can stop with identification. By re-interpreting these small objects on a larger scale, I attempted to draw attention to the exotic in the commonplace, the exquisite in the familiar.

The carvings are in Forest of Dean stone. Originally I planned to make three; one of a pine cone to be sited beneath a Scots pine tree and two more in the forms of an acorn and cup to be sited under an oak. In the event, however, having roughly shaped the acorn and cup, I found the two carvings together became rather too literal, the acorn seemed superfluous, it added nothing and I became increasingly interested in the cup as a single image. Also, in both cone and cup I was becoming preoccupied with similar concerns of structure and form, surface and volume. The carvings are in no way simply academic enlargements, and both explore the relationship between surface pattern and its implications of integral structure.

The cone is asymmetrical; on one side the surface is low relief pattern, on the other the pattern swells to become full—blown sculptural form, all of which relates to an implied internal structure. I wanted the imagination of the viewer to be drawn beyond the surface into the core of the stone. The acorn too is an investigation of growth, but the unseen element here is the fruit itself, this absence drawing attention to the adjacent oak tree which becomes the complementary element.

I wanted to find a site where both oak and Scots pine grew in close proximity, I also wanted an intimate place, and traversed the forest several times in search of the right spot. Eventually I found a glade where young trees of both species flourished together and

*Peter Randall-Page carving* Vessel.

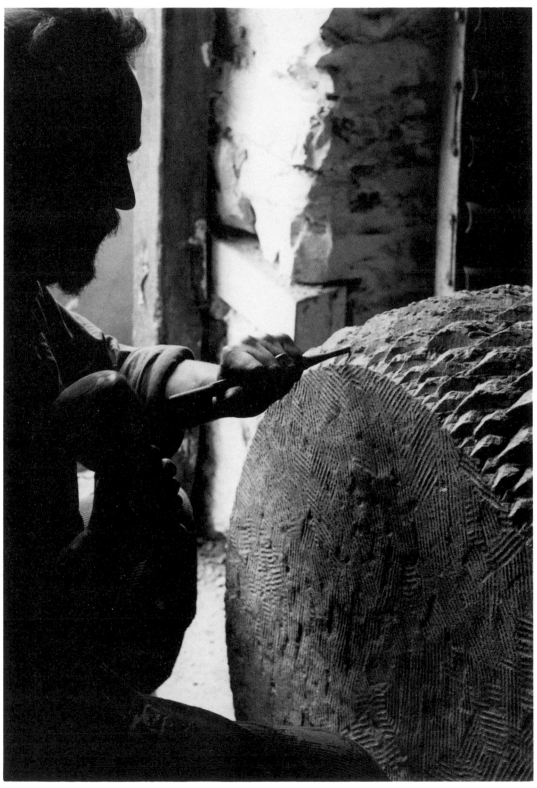

where a small stream winds its way amongst long-abandoned earthworks. It was bounded on one side by what remained of a railway line, and close to a point where several paths converge. Rupert Martin and I decided on the specific location within this area, at the same time working out a route which would cause minimum disruption and destruction to the place. We cleared a stretch of the old railway line from which the site is then approached along a ridge, through a natural avenue of small trees. This route was used to bring the carvings to the site and sub- sequently as a path for the public.

Both pieces are distantly visible from the main path but my hope is that they are not immediately obvious. I wanted the forms themselves, their texture and colour, to be akin to the place and blend with their surroundings; hopefully the growth of moss and lichen will help this process. I would like these works to catch the viewer unawares, perhaps jolting the consciousness into a slightly different way of seeing the forest and our relationship with it.

# STUART FROST
## Bracken Ring and Bracken Knot

My first thoughts on the forest left me feeling how difficult it would be to make something that would not give the impression that it was competing with its surroundings. As I actually worked in the forest I became more aware of its natural beauty and so stayed away from what might have been good sites for sculpture to be brought to and placed in. The ideas for the works came from the materials in the first instance, but hold references to other things. I have been back to the forest a number of times and on two separate occasions people have asked me, "Where is the Bracken Ring? We have looked everywhere for it, but we can't find it." I hope people keep looking as now they are discovering things in the forest that have always been there, but which they didn't look at or notice before.

The bracken sculptures were made by first fixing wood together to form a loop/circle; then stripped stalks of bracken were wound around and around until the desired form was reached. Working in the forest I used only what came to hand. I remember when I first started working directly in the land- scape, I took so much equipment with me that I really didn't know where to start or what to use first. It was almost like moving my studio outside, but without the plug sockets.

# MILES DAVIES
# House

I already knew the Forest of Dean quite well having assisted Magdalena Jetelovà with the construction of the 'Giant's Chair' the previous year. Whilst there I experienced or sensed a feeling not only of calm but also of solitude, which seemed to pervade the area; a different kind of solitude to that experienced within an urban environment or mountainous landscape, which can feel uncomfortable, even threatening at times. The forest provides a more comforting form of solitude as the trees giving shelter from the elements imbue the area with a sense of timelessness. There is also a sense of mystery within the darker, more dense parts of the forest and the surrounding past industrial workings, in the form of spoil heaps, underground culverts and disused railways.

I wanted to translate this experience into a sculpture evoking the things I sensed about the forest. The starting point was the choice of material; my recent work had been predominantly in steel and this medium seemed appropriate as iron ore is indigenous to the Forest of Dean area and remains of mines are scattered throughout the forest. The shape of the structure was conceived both of feelings evoked in me by the forest itself and as a result of the preoccupations I had been exploring in previous work—the nature of the individual in relation to the surrounding environment, the position of the personal within the structures of society . . . these were ideas that I had previously worked on and they seemed to 'fit' what I had in mind for the forest. The tall linearity of the piece echoed the shape and height of the surrounding trees but was also allied to the image of a mine shaft, the structure was capped by a simple house shape, as a metaphor for the shelter and security of the forest. The linear and angled qualities of the work, while 'fitting in' with the forest, also provided an abrupt juxtaposition visually and conceptually which were to me essential features.

Allowing the steel to rust of its own accord, I felt would give the structure a colour and hue in keeping with the surrounding trees and bracken, and would also be reminiscent of previous industrial workings. In time the rust will gradually eat into the surface which will flake and fall to the forest floor exposing brighter, more vivid patches giving the sculpture a continuously changing colour.

The siting of the sculpture proved to be one of the most difficult tasks; once positioned the 'sculpture' becomes not only the structure itself but also the environment surrounding it. After much searching, a small clearing within one of the denser parts of the sculpture trail seemed most appropriate. During the summer months the structure would be almost totally hidden by the dense foliage, it would not be wholly seen until one entered the clearing—giving the sculpture an element of surprise. Throughout the winter the abstract shape of the sculpture could be seen through the trees, and this shape would take different forms depending on the light, distance and direction, giving approaching walkers a visual puzzle.

Once the plans for the structure were drawn, the process of making it was relatively straightforward. The main problem was one of scale. As the structure had to be made in my studio this entailed frequent visits to the forest, and the making of a small maquette to ensure that I had got the proportions right. The steel was cut to pattern with oxy-propane cutting gear, and clamped in position in the studio. With all the arc welding completed, the entire surface of the structure had to be ground; to flatten the welds and expose the bright steel, enabling the sculpture to rust evenly and quickly when in position.

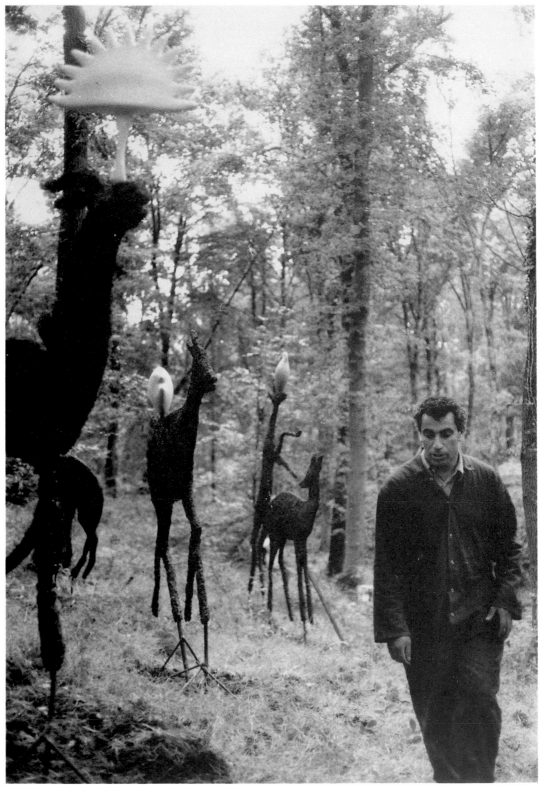

# ZADOK BEN DAVID
## "As there is no hunting tomorrow"

Six months before I started working on this project, I visited the Forest of Dean for the first time. I remember being fascinated by the variety of the landscape and the colours; hills and valleys—the open and the intimate.

Gradually I found myself more interested in the concept of keeping the spirit of the wood with its natural habitat, yet at the same time adding new images which seem at odds with the environment. I wanted to make a group of sculpture as part of an intimate surrounding. I built a group of deer, all black like their own shadows, mostly facing in one direction, and yet each one acting as if he is alone in the forest, caught in his own world, with his own fantasy visible. To achieve this I used very bright colours to stress both the alienation and the individuality.

*Zadok Ben David during the installation of his sculpture,*
As there is no hunting tomorrow.

# IAN HAMILTON FINLAY
## Vincennes

*The heat of the summer was this year
(1749) excessive. Vincennes is two
leagues from Paris. I went on foot, and
walked as fast as possible, that I might
arrive the sooner. The trees by the side
of the road, always lopped, afforded
little shade. One day I took the
MERCURE DE FRANCE, and as I
walked and read I came to the
following question, proposed by the
Academy of Dijon, for the Prize
of the ensuing year: HAS THE
RESTORATION OF THE ARTS AND
SCIENCES HAD A PURIFYING
EFFECT UPON MORALS? The
moment I had read this I seemed to
behold another world and become a
different man.*

*J-J Rousseau, Confessions*

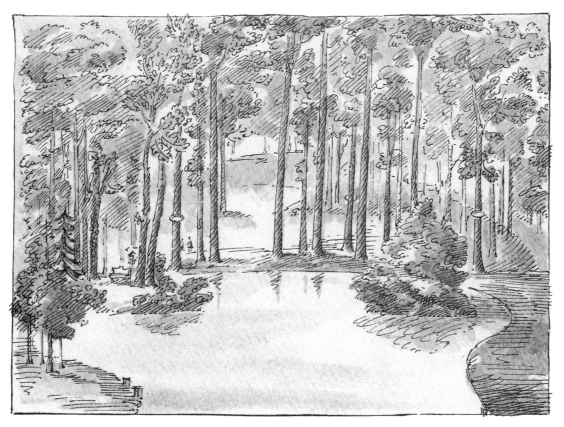

## A PROPOSAL FOR THE FOREST OF DEAN

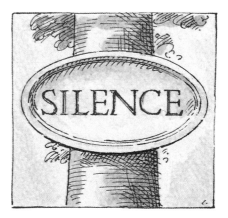

Three oval stone plaques are added to three trees in a quiet woodland. Calling attention to the peaceful surroundings, the plaques are inscribed with the words *SILENCE* (English, French), *SCHWEIGEN* (German), and *SILENZIO* (Italian).

Ian Hamilton Finlay and Gary Hincks, after the drawing by William Kent, *Ponds in woodland groves.*

Wild Hawthorn Press, 1988

# BRUCE ALLAN
## Observatory

I was overwhelmed by the scale, energy and presence of the trees, and spent several days tramping through Beechenhurst on and off the paths looking at what was there, getting a feeling of the place and wondering how my own ideas might fit in. I took along with me the knowledge that globally forests and jungles are being stripped, exploited for timber and cleared for farming. However, despite the historical exploitation that has happened in the Dean (mining of iron ore and coal, felling trees for timber, ship-building and charcoal), there exists in the forest an intimacy peculiar to no other place that I know. It is found in the relationship and scale of man's workings in the land-scape, much of which is now redundant and returned to nature. The intimacy is also evident in place names, particularly those of collieries like Speculation, Rose in Hand, Prospect, New Found Out, No Coal, Work or Hang.

During the first visits to the forest I became aware of the abundance of man-made marks in the landscape. I started to explore an area around Cannop Brook and decided that instead of making a new object sculpture, I would construct a photographic work entitled *Equivalent Forms*. I proposed to document a number of man-made forms including a section of conduit and an old river bed that the conduit had displaced and present them as sculptural equivalents. In this way I hoped to draw attention to the legacy of human intervention in the land-scape without the need for further direct instrusion into it. This was the basis of my first proposal.

The second proposal, *Observatory* came directly from the ideas I had begun to explore in the first. *Observatory* is situated by a pond in an area of thinned trees bounded by thicker plantations. This is the area it influences and in turn is influenced by. *Observatory* offers two vantage points, a viewing platform at the top of a staircase and a small room under the stairs with a seat. I hope that both places offer the chance of a detached view of the forest one walks through. It is painted black, not for dramatic purposes but rather as a foil to the light and life of the forest. Placing it by the pond made me conscious of the part that water and sunlight play in the forest's growth.

The pond is sheltered and often has a still surface that mirrors the trees. At one time it acted as a small reservoir, storing water that was pumped to the Speech House. It is dammed on one side forming the only straight line in this part of the forest, and this line should be seen as a counterpoint to the base line of the sculpture which runs in parallel. *Observatory* points out the move-ment in the trees. Shifting sunlight and shadows camouflage the sculpture and trace the movement of the sun. The understairs room faces north-east and remains a dark space at all times.

I am grateful to Gary Trigg for his hospitality to myself and others, and for the warmth, friendship and interest of several old forest-ers, including Stan Short. Retired as a miner in 1959, 'Short Stan' is 87 and goes for a seven mile walk every Sunday. I've since seen him acting as a guide on the trail. Two other miners introduced themselves as the two Bills unpaid, still working as freeminers, who understood the dark understairs space, and saw the view, a frame of light and colour, as the same as that from within the entrance to a mine.

# CORNELIA PARKER
## Hanging Fire

When I visited the forest in December, it was raining gently and the place seemed to glow as if it were twilight. There was a feeling of being underwater, the bare trees were rimed with green, covered as they were with various lichen. This green vibrated against the bright orange floor, carpeted with leaves and pine needles. I was struck by the spirituality of the place, its hush that you might experience on entering a small church. (Later I pondered on the thought that forests were probably the first churches, and on how they were used to build the great cathedrals.) I half expected to encounter something quite extraordinary, a feeling that kept me looking upwards and over my shoulder as we walked.

When considering the piece I should like to make, the idea that the sculpture should hang aloft in a tree persisted. The impression I wanted the sculpture to create was that of a natural phenomenon or a magical vision, but also of something ancient, as old as the forest. To invoke this feeling of age, cast iron seemed a very appropriate material to use. As well as being one of the first metals used by man and indigenous to the Forest of Dean, I liked the fact it would record the damp atmosphere and echo the colours of the place by rusting. Thinking of an image that would encourage this idea of elusive eternity, fire sprang to mind, a flame that would perpetually burn because it was cast in iron. A circle or fairy ring was another image that kept recurring, this evolved eventually into a crown. The image that I arrived at, that satisfied my first intentions, was that of a crown of flames hanging upside down in an oak tree.

The idea of the piece *Hanging Fire* evolved over a period of time after the initial visit to the forest. I worked on the sculpture in my London studio, modelling the flames out of clay and casting them in resin. These patterns (three different interlocking flames) I sent to Cannop foundry in the Forest of Dean to be cast in iron. I had a steel ring 5′6″ in diameter welded, reinforced within by two slightly smaller hoops; this would be the armature from which to hang the flames.

When installing the piece I spent a week in the forest becoming familiar with the sculpture trail and trying to find a suitable site for *Hanging Fire*. In my proposal I envisaged the work falling from a large oak tree, but looking more closely at their baroque branches I realised that a more uncluttered space was needed for the piece to be effective, after exhaustive searches the ideal spot was found, a circle of five tall sycamores around a central tree. They grew tall and straight and there were no branches till about 25′ up, approximately the height from which I wanted the crown to hang.

The next step was to liaise with Rupert Martin and the Forestry Commission to make sure the trees would take the weight, that they would not be needed to be felled and that there was enough access for a lorry with a hoist to get to the spot. Luckily all these issues were discussed quickly and the site was approved.

The actual installation of the piece was more problematic. The foundry finally completed the flames for the Friday before the opening on Sunday, giving only Saturday to put up the crown and allowing no margin for error. Saturday dawned a wet (thankfully not windy) and miserable day. The help turned up, two foresters in a landrover with a hoist, Miles Davies, another of the sculptors to lend his expertise, and a tree surgeon with his

truck (with a 40' hoist got in at the last minute in case of problems). Problems there were; the landrover got stuck in thick mud and took an hour to free, the tree surgeon had great difficulty in getting his lorry through the trees and decided to fell a couple of small ones to make a path, wielding his chainsaw at the slightest resistance. When we did at last arrive at the clump of trees, five cables were swiftly attached to the uppermost branches of the circle of trees by the tree surgeon (at a height of 35'), after which he had to depart. The landrover was then backed up to the central tree so we could hoist up the hoop of steel (which had been cut then re-welded around the trunk) and attach the cables. The hoist on the landrover refused to function, it had broken. Two hours elapsed whilst the head forester, John Anderson, drove twenty miles to his home, to bring in his own scaffolding so we could carry on with the installation.

The scaffolding proved to be the perfect answer (we realised it would have been impossible to hang the crown with only the hoist). Built up around the central tree it enabled three people to be on top to position the hoop. I directed from below; trying to get the hoop horizontal was a nightmare and was achieved with much fiddling after a couple of hours. The five cables were attached at equal distance around the circle and then the first tier of flames was attached, one flame at a time with twisted strands of copper wire. The flames had been rusted overnight by immersing them in salt water. As the two other tiers of flames were hung I was becoming excited as the crown I had visualised in my head, and on paper, began to emerge as dusk was falling and the rain poured. By the time it was completed it was pitch black. We took down the scaffold in the light of the landrover's headlights, much elated and relieved to have got it up in time.

---

# Coda: Thoughts of an artist-in-residence

My five week residency started in mid-August. I spent my first few days walking and walking; the possibilities for sculpture were endless, many of these I discounted as not being feasible considering time, facilities and cost. Rupert Martin had invited me to do a residency knowing I differed from the previous artists in the fact that I worked in man-made materials, metals such as copper and lead. I had to resist making work out of the natural materials in abundance around me. I wanted to leave an urban mark on the forest, to make reference to its industrial history, but slowly my rural past (I was brought up in the country on a small holding) began to re-emerge and my initial intentions became blurred. I became immersed in the spirituality of the forest, and in my trance-like walks began to forget the industrial imagery and to collect favourite spots, trees and atmospheres. I found myself, like other ramblers, gathering leaves and tree fruits to identify when I got back to my caravan. As I walked

continuously around the forest I began to be attracted to the dead bits; a tree that had fallen and been caught in another. The dead roots had, for some reason, been cut off a long time before, leaving a stump inexplicably hanging in space; a stagnant pool dotted with rotting trees abundant in bracket fungi; a beech tree that had very few leaves due to lack of light. These spots I wanted to reclaim, to draw attention to their poignancy, a sculptural requiem or elegy.

Every Saturday during my residency I would give a guided tour to visitors to the sculpture trail. They would respond in varying degrees of hostility or appreciation to the work, occasionally they would jokingly point out imaginary sculptures along the route as they started to appreciate the forest in a sculptural way. I decided I would like to leave small discreet works along the trail that could almost be mistaken for natural phenomenon

*Cornelia Parker holding two of the 48 cast iron flames for* Hanging Fire.

to provoke even more intimate scrutiny. The trail followers would be on constant alert for hidden sculptures, in contrast to those listed and described on the map. The tours were very rewarding. The public who can be so hostile to 'Art' and may never enter a gallery in their lives, welcomed the interest and controversy the sculpture brought to the forest, a place they felt relaxed and receptive in. During the tours people quickly became used to the idea that sculpture could exist off a plinth and be site specific. The locals and forestry workers had been won over slowly to the trail, helped by the contact they had with the process and the outgoing personalities of the previous artists-in-residence. They had come to love certain pieces and used others as scapegoats on which to air their grievances. They never tired of them as conversation points and positively relished the arrival of a new crop of work and sculptors.

The work I made over the weeks of my stay took the form of three small pieces. The first, a series of nine small copper crowns (approx $10'' \times 10'' \times 5''$) encircled in copper leaves. The crowns were already patinated to a verdigris green, the new copper leaves I hoped would eventually become green as the real leaves were becoming copper. As there were nine crowns, each represented a different species of tree. These crowns were hung near to *Hanging Fire* as a flurry of falling leaves in the denuded beech tree I had come to love in my wanderings. Like the rusting iron flames they would chemically change colour, from copper to green.

On the hanging tree stump I mentioned earlier, I nailed individually modelled sheet lead oak leaves to form an unravelling wreath, the central leaf appearing to be on the point of dropping off to join a small pile of dead leaves on the ground. This piece I called *Unravelling Oak*. I liked the idea that the whole tree was made up of hundreds of layers of tightly packed leaves that when they died unravelled like an endless chain of D.N.A. The third piece was for the stagnant pond; to two dead trees I attached hand-fashioned sycamore leaves cut out of sheet lead. They were nailed to the trees then bent upwards to mimic bracket fungi that was covering the nearby rotting stumps.

# STAND AND STARE: Initial Document, 10 March 1983.

Woods and forests have inspired feelings of awe, dread, poetry and romance over the centuries, particularly in Northern Europe. By the end of the nineteenth century two movements had interrupted this flow in inspiration. Our population had largely fled to the cities and there had been extensive loss of woodland to agriculture and urban development.

Since the 1950's there has been cheap transport for urban dwellers and encouragement to visit the countryside where there are many new forests. The forests they see are often managed for timber production and encouragement to visit has rested on explaining the skills of forestry—a public relations exercise.

There has been little attempt to reawaken the poetic feelings in visitors despite the fact that it should be easier in the present day since some of the greatest fears such as the highwayman, wolf, bear and wild boar are missing. The greatest perceived risk is probably one of getting lost on a walk.

As the new forests mature their interest increases permanently. The felling programmes bring changes of shape and colour on the hillsides and the different types and ages of trees bring welcome diversity—what is now needed is to show visitors what a source of pleasure and wonder this diversity can be. So far we have relied on foresters and scientists to identify and classify the diversity and to write popular trail guides about it. What is needed now is to encourage visitors to stand and stare, to reawaken their sense of wonder and romance.

This may best be started by an awakening of all the senses: sight, hearing, touch, taste and smell in a woodland setting and by a recognition of the primeval provision which forests have made to man down the centuries of mystery, religion, poetry, shelter, fuel, food and drink.

Martin Orrom
Private Forestry and Environment Officer for West England Conservancy
Forestry Commission.

# BIBLIOGRAPHY

*Ian Hamilton Finlay: A Visual Primer,* Yves Abrieux, Reaktion Books, London, 1985

*Kevin Atherton, A Body of Work, 1982–88,* Serpentine Gallery, London 1988

*Earthworks and Beyond:* Contemporary Art in the Landscape, John Beardsley, Abbeville Press, New York, 1984

*The Life of Henry Moore,* Roger Berthoud, Faber & Faber, London, 1987

*Henry Moore: Sculpture and Drawings,* Volumes 2–6, Ed. Alan Bowness, (Volume 1 Ed. David Sylvester), Lund Humphries, London, 1944–88

*The Unpainted Landscape,* Ed. Simon Cutts, Coracle Press, London & Graeme Murray Gallery, Edinburgh, 1987

*Zadok Ben David; Sculpture,* Benjamin Rhodes Gallery, London, 1987

*The Secret Forest of Dean,* Fay Godwin, Redcliffe Press/Arnolfini, Bristol, 1986

*Andy Goldsworthy, Parkland,* Yorkshire Sculpture Park, Bretton Hall, Wakefield, 1988

*Barbara Hepworth, A Pictorial Biography,* Barbara Hepworth Museum, St Ives, 1978

*Magdalena Jetelová, Sculpture,* Riverside Studios, London, 1985

*A Sense of Place: Sculpture in Grizedale Forest,* Ed. Tony Knipe and Peter Davies, Ceolfrith Press, Sunderland, 1984

*Stoneworks: Sculpture at Powys Castle,* Ed. Tamara Krikorian and Michael Nixon, Oriel 31/ Davies Memorial Gallery, Newton, Powys, 1988

*Music in Stone: Great Sculpture Gardens of the World,* Ed. Sidney Lawrence and George Foy, Scala Books, New York, 1984

*New Milestones: Sculpture, Community and the Land,* Joanna Morland, Common Ground, London, 1988

*British Sculpture in the Twentieth Century,* Ed. Sandy Nairne and Nicholas Serota, Whitechapel Art Gallery, London, 1981

*David Nash, Wood Primer,* Annely Juda Fine Art, London, 1988

*A Quiet Revolution: British Sculpture since 1965,* Ed. Terry A. Neff, Thames & Hudson, London, 1987

*Art for Architecture,* Ed. Deanna Petherbridge, HMSO, London, 1987

*The Forest of Dean,* Humphrey Phelps, Alan Sutton, Gloucester, 1982

*Keir Smith, The Dreaming Track,* Artsite, Bath, 1985

*Open Air Sculpture in Britain,* W. J. Strachan, Zwemmer, London 1984

*The Language of Sculpture,* William Tucker, Thames & Hudson, London, 1972

*Art Within Reach,* Ed. Peter Townsend, Art Monthly/Thames & Hudson, London, 1984

*The Green Book,* Redcliffe Press, Bristol. Special sculpture issue, including article on Ian Hamilton Finlay, Vol III No. 1; article on David Nash, Vol III No. 2; on Peter Randall-Page, Vol III No. 5.

# SCULPTURE TRAIL

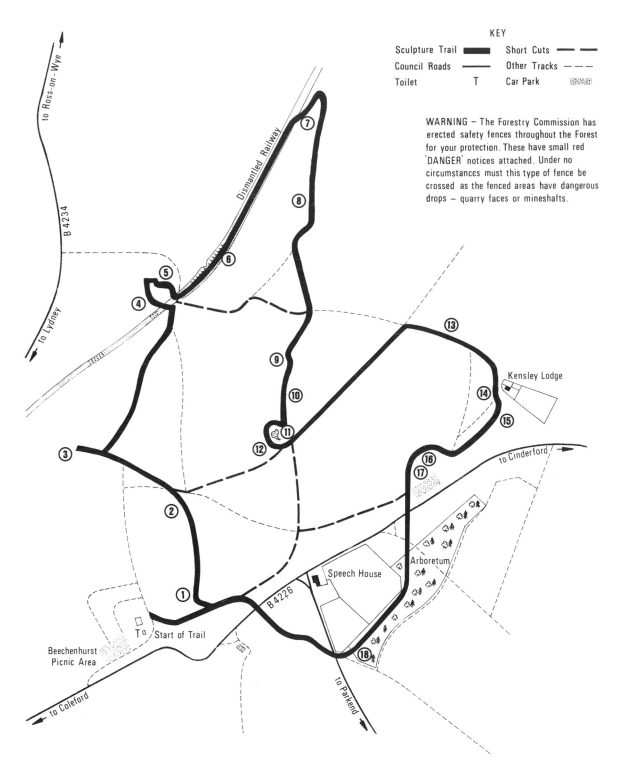

**KEY**

| | |
|---|---|
| Sculpture Trail ▬ | Short Cuts ▬ ▬ |
| Council Roads ── | Other Tracks ‒ ‒ |
| Toilet T | Car Park ▨ |

WARNING – The Forestry Commission has erected safety fences throughout the Forest for your protection. These have small red 'DANGER' notices attached. Under no circumstances must this type of fence be crossed as the fenced areas have dangerous drops – quarry faces or mineshafts.

to Ross-on-Wye

B 4234

to Lydney

Dismantled Railway

Kensley Lodge

to Cinderford

Arboretum

Speech House

B 4226

Start of Trail

Beechenhurst Picnic Area

to Coleford

to Parkend

# KEY

1. Melissa's Swing – Peter Appleton
2. Place – Magdalena Jetelovà
3. Heart of the Stone – Tim Lees
4. Black Dome – David Nash
5. Fire and Water Boats – David Nash
6. The Iron Road – Keir Smith
7. Conc and Vessel – Peter Randall-Page
8. Grove of Silence – Ian Hamilton Finlay
   Vincennes – Ian Hamilton Finlay
9. As there is no hunting tomorrow – Zadok Ben David
10. House – Miles Davies
11. Crossing Place – Sophie Ryder
12. Observatory – Bruce Allan
13. The Four Seasons – Yvette Martin
14. Wind Chimes – Peter Appleton
15. Cathedral – Kevin Atherton
16. Hanging Fire – Cornelia Parker
17. Falling Crowns – Cornelia Parker
18. Sliced Log Star (Inside-out Tree Piece) – Andrew Darke